D0320318

image art
workshop
Paula Guhin

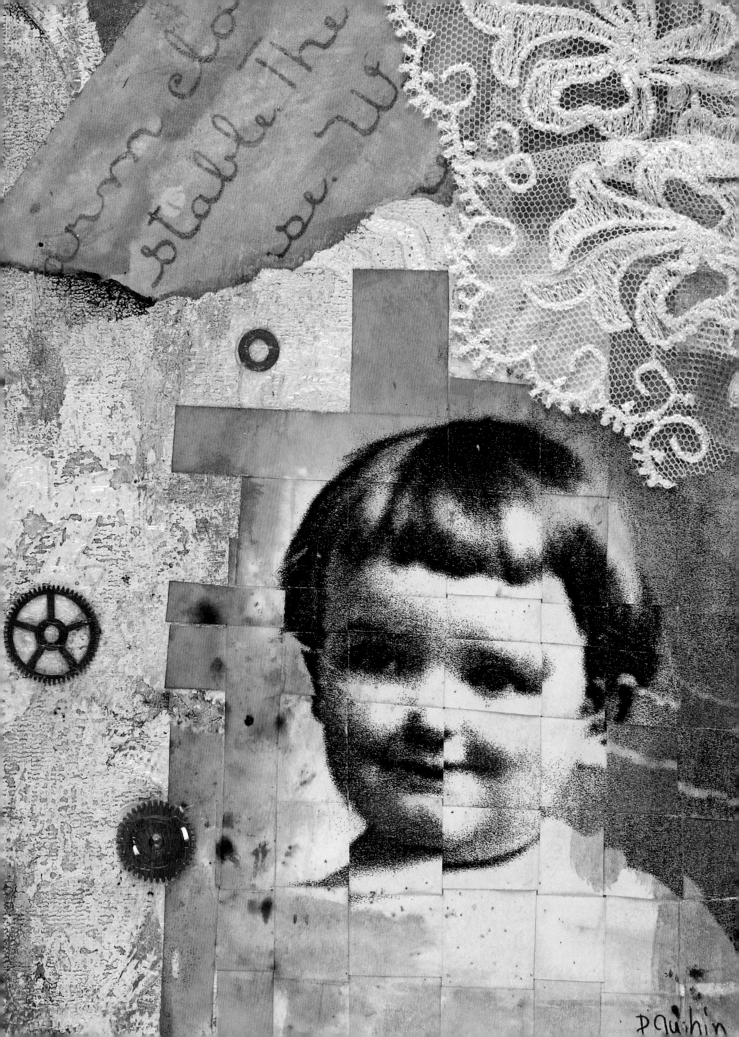

image art
workshop

Paula Guhin

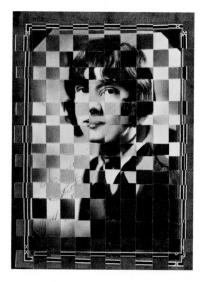

Creative Ways to Embellish and
Enhance Photographic Images

**Creative Publishing
international**

www.creativepub.com

acknowledgments

Thanks so much to everyone who contributed to *Image Art Workshop*. And special credit to Linda Neubauer and the delightful, enthusiastic team at Creative Publishing international.

I'll be forever appreciative of my late mother, Ida, the most inventive person I've ever known, and of my husband, my world, David.

BLACKBURN COLLEGE
LIBRARY

Acc No. 6628314

Class No. 770 GUH

Date OCT 09

Creative Publishing international

Copyright © 2009
Creative Publishing international, Inc.
400 First Avenue North
Suite 300
Minneapolis, Minnesota 55401
1-800-328-3895
www.creativepub.com

All rights reserved.

Printed in Singapore
10 9 8 7 6 5 4 3 2 1

Library of Congress Cataloging-in-Publication Data

Guhin, Paula.
 Image art workshop : creative ways to embellish and enhance photographic images / by Paula Guhin.
 p. cm.
 ISBN 978-1-58923-450-5
 1. Photographs--Trimming, mounting, etc. 2. Photograph albums.
3. Scrapbooking. 4. Photography, Artistic. 5. Scrapbooks. 6. Photography-Retouching. I. Title.

TR340.G84 2009
770--dc22
 2008053954

President/CEO: Ken Fund
Vice President/Sales & Marketing: Kevin Hamric
Publisher: Winnie Prentiss
Acquisition Editors: Linda Neubauer, Deborah Cannarella
Creative Director: Michele Lanci-Altomare
Production Managers: Laura Hokkanen, Linda Halls
Senior Design Managers: Jon Simpson, Brad Springer
Design Manager: James Kegley
Photographer: Joel Schnell
Photo Coordinator: Joanne Wawra
Copy Editor: Catherine Broberg
Proofreader: Ellen Goldstein
Book Design: Tina R. Johnson
Cover Design: Jon Simpson
Page Layout: Tina R. Johnson

IMAGE ART WORKSHOP
by Paula Guhin

Visit www.Craftside.Typepad.com for a behind-the-scenes peek at our crafty world!

Due to differing conditions, materials, and skill levels, the publisher and various manufacturers disclaim any liability for unsatisfactory results or injury due to improper use of tools, materials, or information in this publication.

All rights reserved. No part of this work covered by the copyrights hereon may be reproduced or used in any form or by any means—graphic, electronic, or mechanical, including photocopying, recording, taping of information on storage and retrieval systems—without the written permission of the publisher.

contents

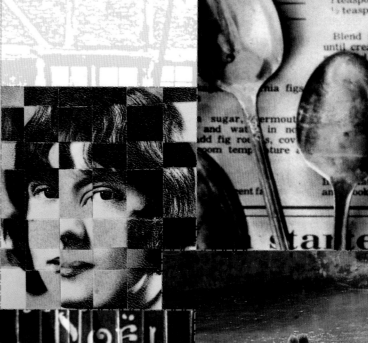

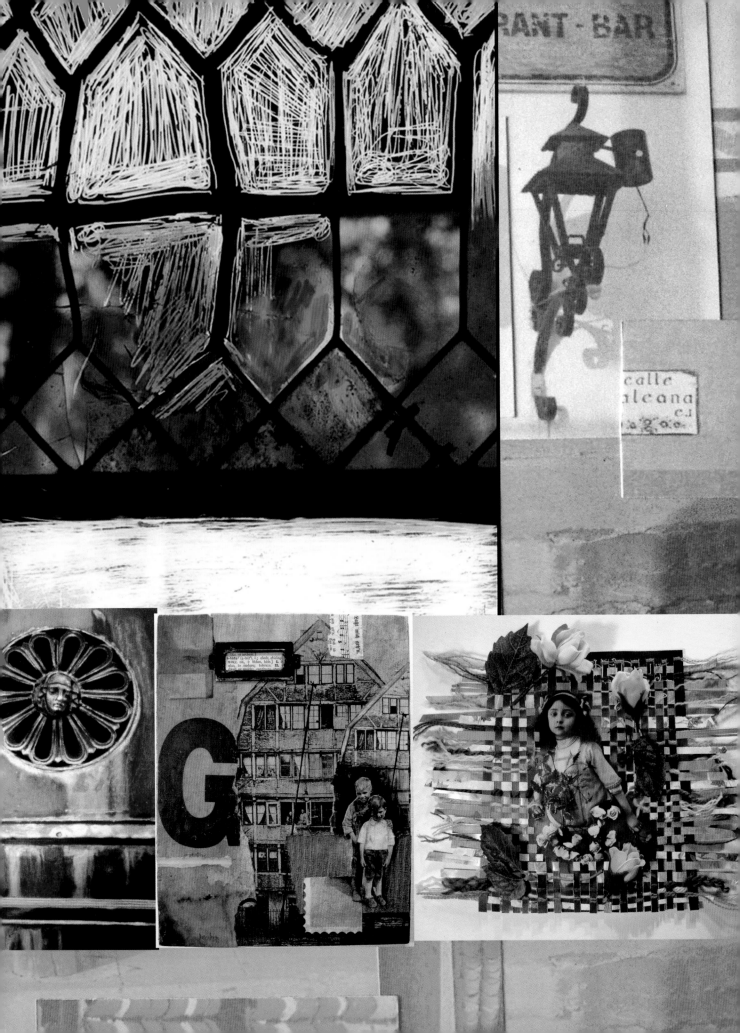

introduction

This book explores **new ways** to **cut, color, collage,** and **transform** photographs using a **variety** of **artistic** techniques.

Recycle all those loose, spare photos, including those that are less than successful. Or physically alter photocopies, even magazine pictures. Preserve and share memories with ingenuity, and use these mixed-media creations in journals, scrapbooks, and much more. Or make original art—even assemblages—with heart and meaning.

Hands-on manipulation is at the heart of this book. It will reveal that everyone has the ability to embellish and enhance pictures in exciting ways. Although some of the processes involve a computer or photocopier, the emphasis is on reworking images by hand. Even those people who don't believe they're artistic—and children too—can succeed with these projects.

Most of the activities require inexpensive materials that the majority of households already have, such as scissors, glue, markers, or colored pencils. Plus, most projects take less than an hour to complete.

Each chapter offers a materials and tools list, as well as step-by-step directions enhanced by tips and full-color illustrations. You can adapt the processes using diverse design ideas and materials. See the Artists' Gallery on page 130 to stimulate the imagination even more.

Paint and Mark It Up

The book begins with many inspiring tactics for colorizing and making marks on or around photos. Even people who say they can't draw or paint will gleefully discover their hidden talents. The first part also reveals tips and techniques for transforming images with paints, markers, bleach, scratch tools, colored pencils, pastels, and dyes.

Be a Real Cut-up

The second section focuses on fun ways to cut and paste (literally)! Make a lovely montage of textures or patterns, or combine faces or figures in charming permutations.

Creativity with Copiers and Computers

Segment three gets playful with photocopies, graphic transparencies, and digital images.

3D Delight

The final section presents ideas for taking images into the third dimension. Extend flat pictures into space, or adorn handbags or other vessels with personal photographs.

Let the adventure begin! But before we embark on this experience, a reminder to take care when using bleach, toxic substances, or craft knives.

Now fire up and get under way. Explore the book's techniques solo or with friends or family. Allow the ideas to spark your own creativity, self-expression, and experimentation. Imagine the possibilities.

paulaguhin

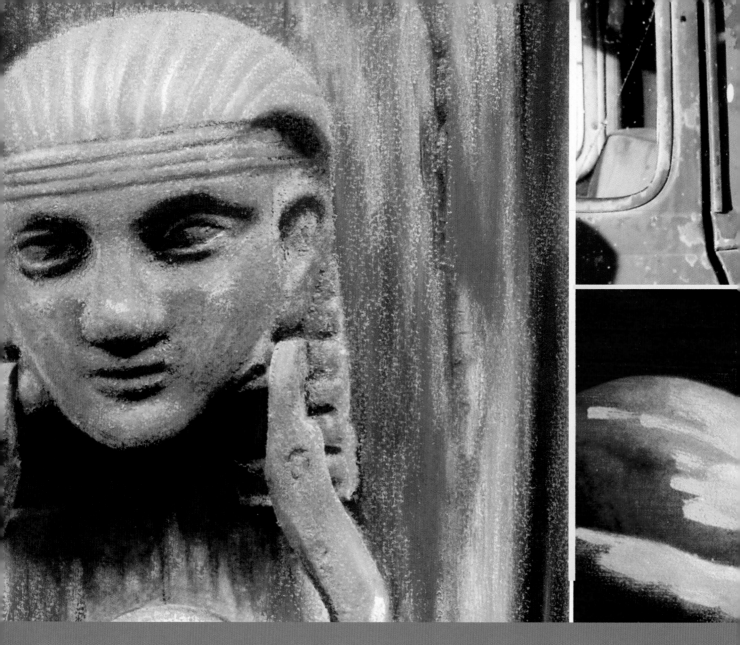

Paint and Mark It Up

MVSEI VATICANI

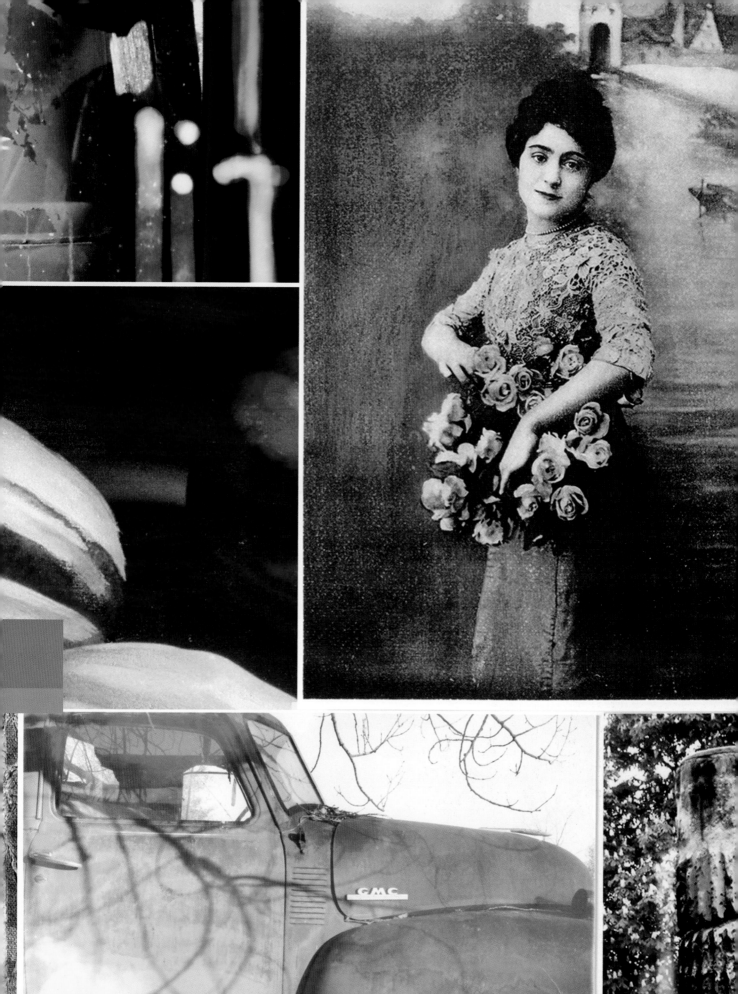

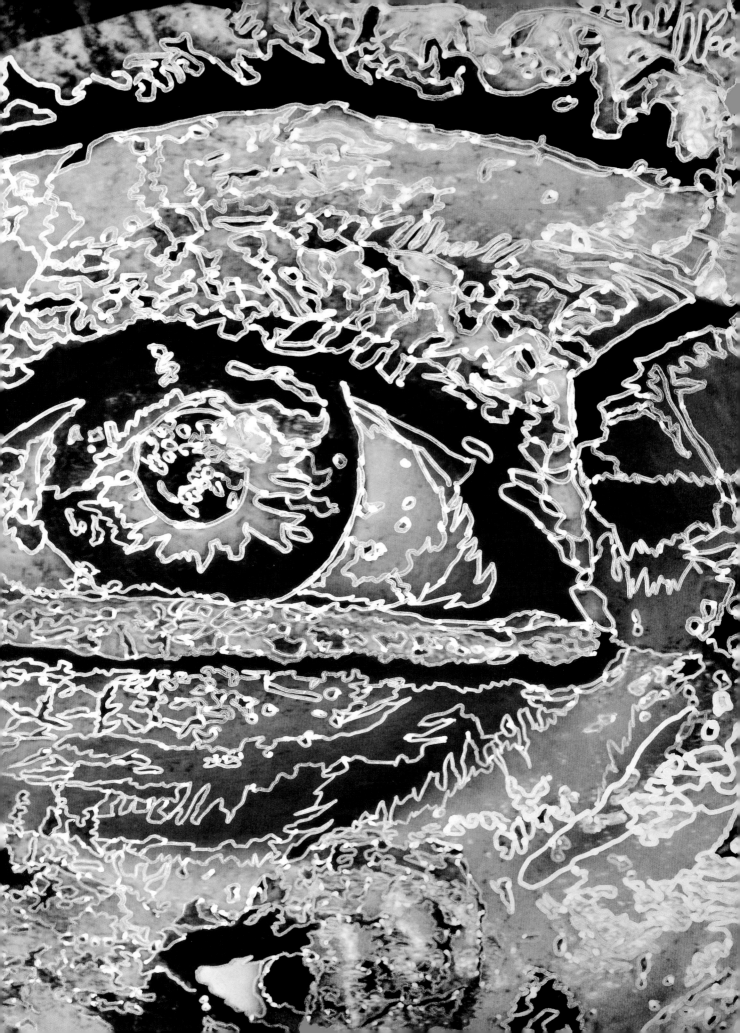

the magic of markers

Of course, the colorizing of black and white photographs is traditional.

But sometimes our color prints let us down, and improving or modifying them is easy with markers. Wide or fine-line, permanent or water-based, markers and fiber-tipped pens exist in great variety. Try them in vivid jewel tones, pastel colors, even fluorescents.

materials and tools

glossy photograph

markers

cotton swabs, cotton pads, or a lint-free cloth

sealant spray (optional)

Broader-tipped markers are better for colorizing larger areas. The extra-fine-line markers shown here are suitable for outlining shapes. Permanent markers tend to leave streaks more readily than water-based ones.

the magic of markers (continued)

Selecting a Photograph

A glossy or luster-surface photograph is easier to colorize with markers in larger areas, but lab-processed matte prints may work too. Certain inkjet prints are not adequate, especially if the prints are matte. Steer away from very dark photos as well, as many markers are too transparent to be effective with them.

Blending

Work in a small area at a time and blend the strokes together immediately. Using a circular motion, smooth the color to a thin, even layer with a swab, a clean, dry cloth, or fingers!

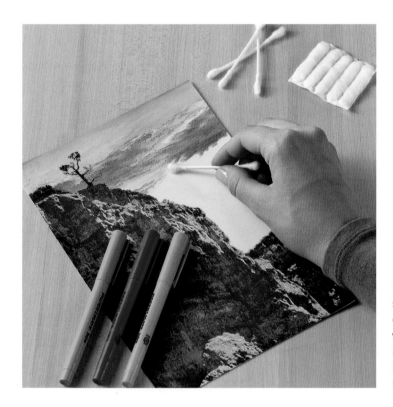

Use a lint-free cotton pad or swabs to smooth out a small area at a time. Clean out highlights without delay, buffing firmly with clean cotton. Maintain accuracy along borders if you wish to avoid unwanted hues in adjacent areas. Color selectively or rework the entire picture.

Before

After

The original color enlargement was rather drab.

Water-based markers enhance and intensify the nostalgic mood.

Here's an example of selectivity (choosing only a portion to color).

A creative soul may prefer frankly fake colors and obvious strokes at times. Permanent markers lend themselves to streakiness.

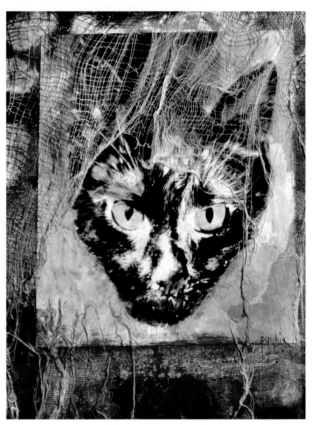

Discerning artists often add color to limited portions of black and white works, as shown here. Other materials here include cheesecloth, acrylic paint, and a canvas board as support.

Formerly, this was a monochrome (tints and shades of one color) photograph mounted on a canvas board. Markers, modeling paste, and acrylic paint add interest.

Borderlines

Add scores of contour lines to accentuate shapes on color images. Good photo-editing software often includes ink outlines filters, yet there's something tranquil and gratifying about doing it by hand, the old-fashioned way!

Lots of Lines Bump up the Bang

Use very thin black, colored, or metallic permanent markers to outline every contour (edge) in an enlarged photograph. Some inkjet prints may not be adequate for this project unless first sprayed with sealant and then allowed to dry.

A great many thin black edges can be powerful, especially on a light or bright picture. Or use extra-fine silver, copper, or gold pens to add elegance. Simply outline every shape, even those defined only by changes in color or values (lights, mediums, and darks).

When finished, the outlined photo-graph need not be sealed if the fine-line marker is permanent.

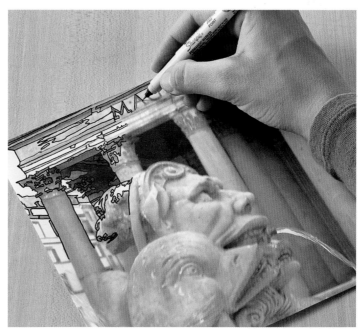

Contour lines from a black ultra-fine-point marker add arty contrast to a very gray photograph.

the magic of markers (continued)

Pointers from Paula

Select line color judiciously. Metallic silver contours might look best with an image of predominantly cool colors, such as blues and violets. Gold or copper ink outlines might better complement "warm" images.

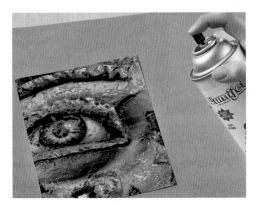

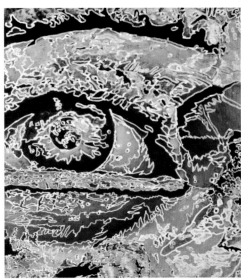

If desired, spray a light coat of clear acrylic on the piece when finished. Keep the can at least 12" (30.5 cm) away and move it continuously while spraying. Always spray fixative in a well-ventilated area.

Before

After

This unaltered enlargement is not quite in focus.

The same image has more dazzle with the addition of metallic gold.

Before

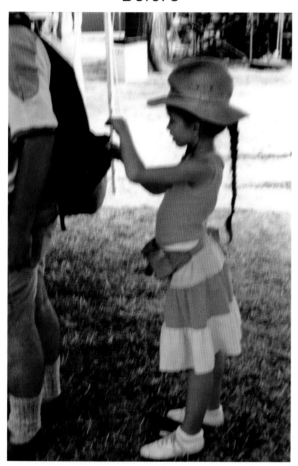

Girl in Hat is a fairly pleasant but blurry photograph, before manipulation.

After

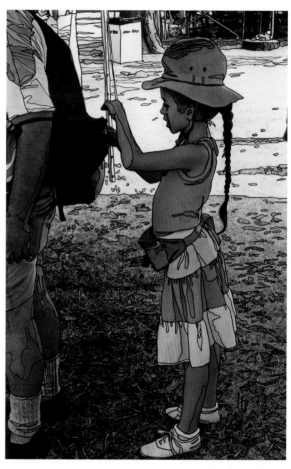

Countless contour lines intensify the zing.

a permanent solution

Opaque oils, acrylics, and watercolors: All of these painting media are delightful for transforming images.

Use them to change unsatisfactory colors, obliterate unwanted elements, or selectively modify just a portion of the picture.

Chalk pastels, oil pastels, and colored pencils also are enduring materials with which to make permanent alterations to a photo. Self-expression—adding one's own interpretation to an image—allows the artist to add to or completely change the mood of the photograph.

materials and tools

photographic enlargement

clear gesso

wide foam brush

artists' tube oil paints, alkyd fast-drying oil colors, or water-soluble oils:
a basic set

palette (a surface used for holding and mixing paint)

bristle brushes in several sizes, with flat and pointed tips (natural bristle or synthetic, but avoid most watercolor brushes)

drawing board or panel

painter's tape or drafting tape

odorless solvent (unless using water-mixable oils)

plastic sheeting and protective clothing

lint-free cloth

retouch spray (optional)

varnish (optional)

Opaque Oil Painting

Employ a classic art medium in effecting a metamorphosis!

In times gone by, photographers hand-colored images (usually black and white photos) with translucent oil colors. Today, artists still use tints, such as Marshall's Photo Oils, rubbing them onto prints. The photographic image shows through the sheer color of such oils.

On the other hand, conventional opaque oil paints are intense colors that aren't see-through unless thinned. They are heavier, and the artist can apply them as thickly as desired. One can even build up texture with brushstrokes or a palette knife. Oils also come in stick form, including iridescent and metallic colors!

Choosing a Photo to Paint

1 People, animals, landscapes, architecture, seascapes, or still life objects—the choices are innumerable. One is not limited to black and white images for this venture. Color enlargements, even inkjet prints will do. Pictures with dreary, lackluster color, or distracting backgrounds are perfect candidates, because improving them is easy with this procedure.

2 Opting for an important photograph that is dear to the heart certainly may move the artist to paint it, but use an enlarged copy, please.

3 An 8" x 10" (20.3 x 25.4 cm) (or larger) photo is an agreeable size on which to paint. A print with good contrast and a variety of values will be even easier to work with.

4 Another consideration is that double-weight or heavyweight papers provide a sturdy foundation for a photo painting.

5 Finally, if possible, have an identical copy of the photo handy to serve as a reference.

Preparing to Paint

1 Tape the photograph by its borders to a drawing board, cutting board, or heavy-duty cardboard. Protect the work area with newspapers or plastic sheeting. Wear old clothing or an apron.

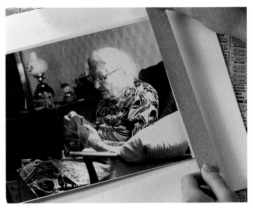

2 Use a wide foam brush to apply a thin, even coat of clear gesso to a silver-based photo or a dye-sublimation print from a photo lab.

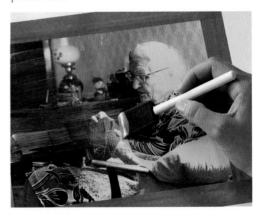

3 Allow to dry thoroughly before continuing. Clear gesso goes on milky but dries to a translucent finish. It provides "tooth" to hold paint better on a slick surface.

Beginning to Paint

1 Squeeze small amounts of titanium white, ivory, black, and other colors onto a palette. You can always put out more paint, if needed. A paper plate can be a convenient and cheap palette, but reusing an old plastic or china plate is better for the environment. Work directly from the pure colors or, better yet, mix up some tints (colors blended with white), shades (colors mixed with black), and lower intensities (colors that are less than bright) on the palette.

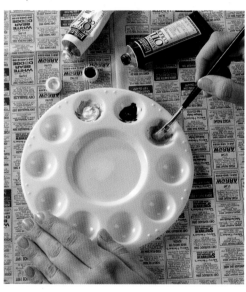

2 The "line of attack" is optional: From top to bottom, from the center outward, from background to foreground (or the reverse), or from the finest or most important details first. The right-handed can even begin at the left and work toward the right if they wish.

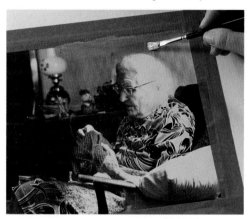

3 Use a precise, tight approach or one that is looser and more painterly, but watch adjacent areas carefully when applying oils to a particular portion. Match paint colors and values to those in the original for a realistic effect, or take a more relaxed, unrestrained approach. Blend with a clean brush.

4 If necessary, thin conventional tube oils with a small amount of odorless turpentine, lacquer thinner, or linseed oil. Clean brushes with low-odor solvent, and store leftover solvent in a glass container. "Aqua" oils and alkyds clean up with baby oil, then soap and water.

a permanent solution (continued)

Pointers from Paula

Brushed-on clear gesso may smear some inkjet or laser prints. With them, and with photocopies on cardstock, you might skip that step and paint directly on the print, especially if the print has a matte finish. Or apply a pre-treatment spray, such as Sureguard Retouch, before painting, particularly if the print has a high-gloss surface.

There are many useful products available with which to prepare surfaces and/or varnish artworks.

Mixing and blending colors is just one of the pleasurable aspects of oil painting. Beware of muddiness, however. Complementary colors (those opposite each other on the color wheel) become murky when mixed together. Purple—yellow, blue—orange, and red—green combinations produce grayed or brownish tones. Use care when painting along the edge of a shape.

Before

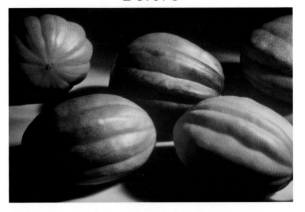

This is the original glossy color photograph.

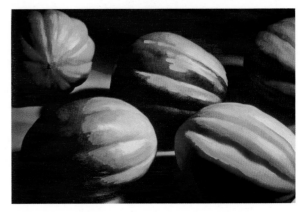

Note the cloudiness imparted by coating the photo with clear gesso. The sequence of oil painting here was to begin with the highlights on the subject.

After

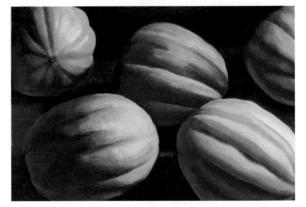

The oil painting is finished in a fairly lifelike manner.

Finishing the Painting

Allow a completed photo-painting to dry for the time recommended for the paints used. Oils may require a week or more to dry (much longer if applied heavily). Water-solubles and alkyds dry somewhat faster. Varnishing, which seals and protects the painting, is optional.

If there is leftover paint on the palette when the painting session ends, slip the palette into a large, resealable plastic bag and press out the air before closing. This will keep it fresh for several days.

Oils in blues and violets convert what was initially a black and white photo.

Oil painting on a lab-processed photo

An oil painting based upon a glossy picture

a permanent solution (continued)

Awesome Acrylics

Make an ordinary image extraordinary with the brilliance of acrylic paints. They dry very quickly and resist water after drying. Paintbrushes must remain wet throughout the acrylic painting session. Clean-up is simple: just soapy water!

materials and tools

- photograph of choice, plus a reference copy if possible

- clear gesso and a wide foam brush (optional)

- tube acrylic paints: a basic set

- palette

- bristle brushes in several sizes and styles

- drawing board or panel

- painter's tape or drafting tape

- container of water

- cloth or paper towels

- plastic sheeting and protective clothing

- retarding medium (optional)

Preparing to Paint in Acrylics

1 Attach the print to a solid, smooth panel.

2 Cover the work area with plastic sheeting or old newspapers.

3 Use clear gesso as sizing on glossy or luster-surfaced photographs, if desired. Apply with a foam brush and allow to dry overnight.

Pointers from Paula

To increase the drying time of acrylic paints, add a product called "retarding medium." This will allow you to work with the paint longer.

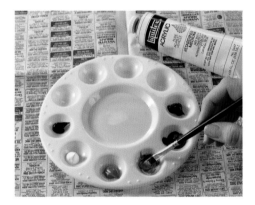

To make acrylics more transparent, just mix with water.

Painting with Acrylics

1 Protect clothing.

2 Keep handy a copy of the print as a comparison.

3 Squeeze small amounts of paint colors onto a palette.

4 Painting techniques vary, so choose the method that best suits the work at hand. An Impressionistic style with rough paint daubs and evident brushstrokes lends itself to many landscapes and still life objects. Or paint smoothly and more accurately in a "tighter" manner.

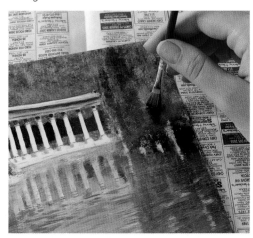

Tapping tiny dots of color by stippling (stamping brush bristles on end) is a technique used here to simulate foliage. Any stiff brush can serve as a stippling brush.

5 Make objects in the painting any color you desire, regardless of reality, or correspond to the hues, tints, and shades of the original.

If an attempt at opaque photo-painting doesn't quite satisfy, let the piece dry and rework it!

Acrylic paintings do not need to be sealed.

Painting a magazine face using just white, black, and one color is good practice in understanding how to create modeling, or form, on a flat surface.

a permanent solution (continued)

Before
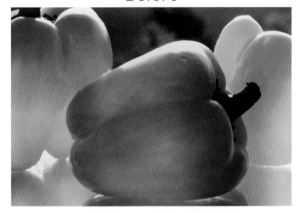

Original glossy lab-processed photograph

After
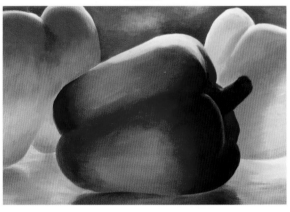

Finished in opaque acrylic paints

Before
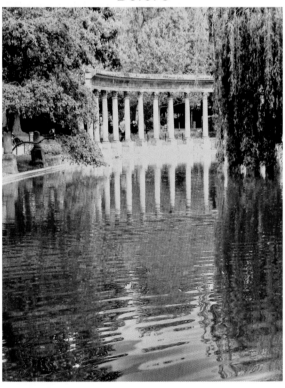

Colonnade, a lab-processed enlargement on semi-matte paper, required no pre-treatment.

After
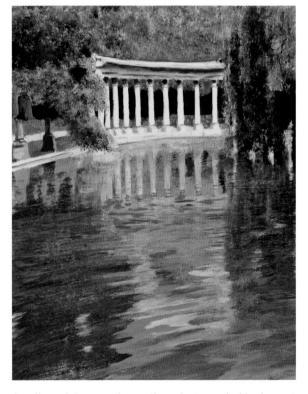

Acrylic paint over the entire photograph blocks out small unwanted details.

Wow Them with Watercolors

Watercolor paint—pigment mixed with water—usually is quite a transparent medium. A "wash" is a film of water-thinned paint or ink spread with a brush. Washes allow underlying lines, shapes, and colors to show through.

Artists' tube or liquid watercolors can be first-rate, but some children's sets of pan or cake watercolors (Crayola or Prang brands, for example) are not only inexpensive and widely available, but quite effective.

materials and tools

photograph

watercolor paints

palette

watercolor brushes

drawing board or panel

painter's tape or drafting tape

container of water

lint-free cloth

sealant spray (optional)

Painting with Watercolors

1 Tape the photograph flat onto a solid, smooth base.

2 Prepare a quantity of thin, watered-down color. Just before painting, moisten an area of the photo with clean water to allow more blending time. Inkjet and laser prints might smear, so work quickly and don't "scrub" with the brush.

3 Since watercolor paints stain photographic emulsion immediately, begin by painting a weak color wash into the watery area. This technique is called "wet-into-wet."

4 The cautious painter can build up the intensity of pale color in layers, wiping off excess diluted paint without delay using a clean cloth.

5 A general rule of thumb is to work in lighter areas first and to add darker or brighter details onto dry areas later, if necessary.

6 When the paint is thoroughly dry, spray with a sealant if desired.

a permanent solution (continued)

Before

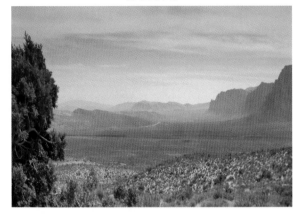

The original landscape lacks drama.

After

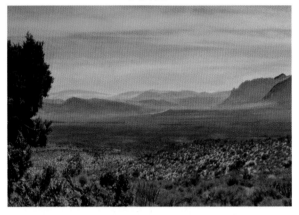

Watercolors add vividness to land and sky.

Pointers from Paula

To keep a part of an image from staining, shield it beforehand. Liquid Frisket is a masking medium that dries "rubbery," protecting certain areas by resisting paint, dye, or ink. Or use rubber cement (in a well-ventilated room)! Remove the masking material later by rubbing or peeling it off.

Use the pads of fingers or thumb to roll off rubbery mask.

Before

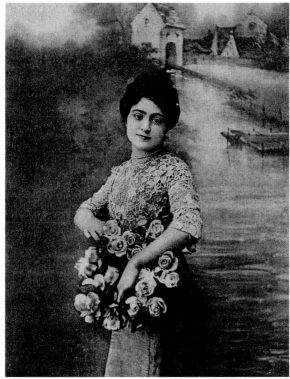

After

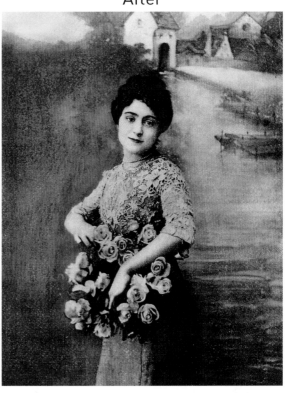

A black and white photocopy on cardstock acquires more charm with watercolors.

Cardstock will buckle when wet, so block it by taping it down.

Before

The colorless original

After

Reinterpreted with watercolor and pen

"Paint" with Pastels

It's a snap to make over an image with soft chalk pastels or oil pastels.

Historically, chalk pastel has been dubbed a painting medium. It is, however, a dry material and is included here as a drawing tool. Oil pastel, while greasy, is both a drawing tool and a painting item as well.

It is a soft, buttery medium that lends itself to impasto effects. To paint with a brush, mix oil pastels with turpentine, lighter fluid, or other solvent. Oil pastels also come in water-soluble form! These allow wet blending and watercolor effects.

materials and tools

photograph (small photos are problematic, so use an 8" x 10" (20.3 x 25.4 cm) image if possible)

clear gesso or spray-on preparation (for glossy papers)

chalk pastels or oil pastels

tortillons, blending stumps, or cotton swabs

eraser for chalk pastels (a kneadable eraser is ideal)

fixative

drawing board or panel (optional)

painter's tape or drafting tape (optional)

plastic sheeting, protective clothing, and disposable gloves (optional)

paper towels (optional)

solvent for oil pastels (optional)

Chalk pastels are user-friendly. Choose the softest, finest pastels for best results. In addition to pastels in stick form, pastel pencils are convenient to use in small, detailed areas. Conté à Paris and Derwent are two fine brands for such pencils.

Applying Chalk Pastels

1 A matte surface, especially watercolor printing paper, may accept pastels without advance groundwork. As we've said before, if the photograph is beloved, make a copy on which to work.

2 Stroke with the tip of the pastel or, to cover large areas, lay the (unwrapped) stick flat on its side. Mixing unrelated colors will result in murkiness, but do combine related colors for a wide range of hues.

3 Leave chalk marks defined or merge them into a soft mélange of colors. Tortillons are soft, pointed tools perfect for merging colors.

4 Save the strongest highlights for last. They're the finishing touch!

5 The surface of a finished pastels work is fragile. It will smudge easily unless sprayed with fixative or framed under glass.

Don't be alarmed when spray sealant darkens the chalk pastels. After they dry, the true colors return.

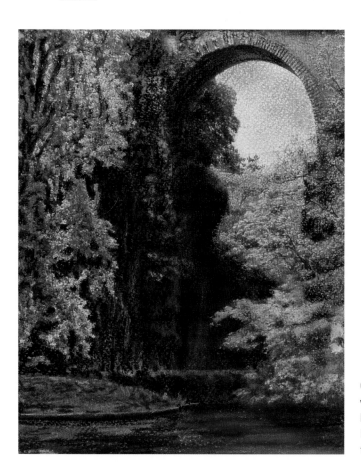

On the right side of this work on inkjet watercolor paper, chalk pastels are blended for a smoother appearance. Distinct strokes are visible on the foliage at the left.

a permanent solution (continued)

Before

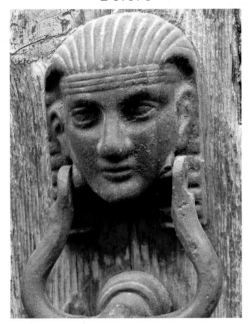

The original pallid photograph

After

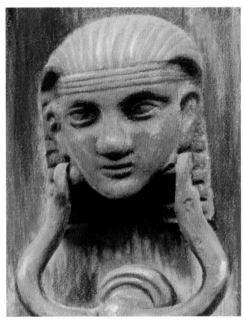

A pale color print on inkjet watercolor paper gets a whole new look with chalk pastels.

Before

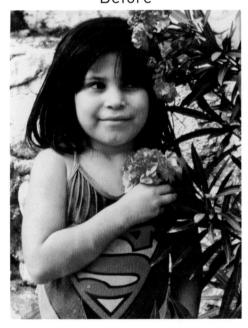

Before, the surroundings detracted from the main subject.

After

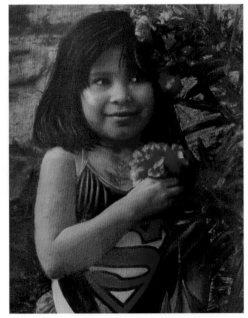

Chalk pastels simplified the background and improved the color scheme.

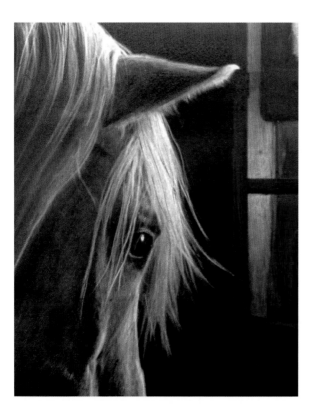

This Conté animal portrait disguises an underexposed photograph.

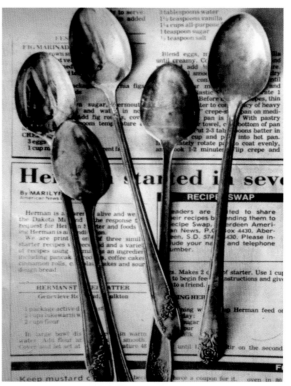

In this black and white photograph, the spoons are heavily colorized with Conté, and the background is lightly tinted.

Applying Oil Pastels

1 Select or print a photo that's not too dark. Add tooth to a glossy-surfaced image with retouch or workable matte spray or with clear gesso. Dry thoroughly.

2 Oil pastels contain pigments that may stain fabrics and other surfaces. Cover clothing and work area with a protective layer. Wearing disposable gloves is optional.

3 Lay down the creamy color as lightly or heavily as desired. Overlay hues to create new ones. Blend with fingers (and use small tortillons in tiny areas), or leave strokes distinct.

4 Remove mistakes with the hard swipe of a cotton swab or scrape away the error with a fingernail. Use a paper towel to wipe tips of pastels when they become contaminated with another color.

5 Preserve the work when finished by spraying with clear acrylic. Art done in oil pastels can smear if not framed under glass or shielded with fixative. In a well-ventilated area, use light, multiple coats of the spray.

Keep all solvents away from children and pets, and work in a well-ventilated area.

a permanent solution (continued)

Pointers from Paula

Some artists use rubber-tipped color shapers when working with oil pastels. Certain eyeliner pencils come equipped with similar wedge-shaped tips.

Black and white C-41 film (such as Kodak's 35mm film for black and white prints) is a great product. You might ask your local photo lab to print your roll with a sepia tone or a blue cast, if such a tinge fits the subject.

Before

After

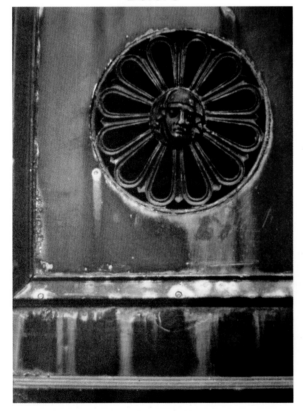 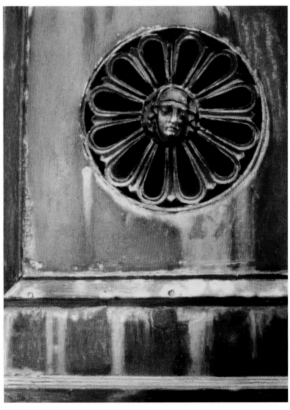

This original image of a rusty iron door has an interesting tone but lacks the impact of color.

Door now converted with oil pastels

A mixed-media collage with oil pastels on the small photo.

Colored Pencils: A Pleasure to Use

Colored pencil, far from being just a children's tool, truly is a fine art medium. Prismacolors are excellent colored pencils, as are Derwent Artist.

Some artists use mineral spirits to blend quality colored pencils, although colorless blender pencils are available as well. There are water-soluble colored pencils that allow for painterly effects, too.

materials and tools

photograph

spray-on preparation such as Sureguard Retouch to add tooth (if the image has a slick surface)

colored pencils

eraser

pencil sharpener

Berol makes a colorless blending pencil to use with their Prismacolors.

a permanent solution (continued)

Applying Colored Pencils

1 Select an image that's not too dark overall—the soft hues of waxy colored pencils work best in lighter areas.

2 Begin by coloring in the shadows very lightly and leaving the highlights white.

In this unfinished work, darker colored pencils tone down the background only on the right half. When the background is done, the main subjects will be completed last.

3 Layer several colors wherever you wish and gently increase the pressure to deepen the shaded areas. Layering adds vibrancy and depth to the picture.

Pointers from Paula

Tone black and white copies of vintage photos a light golden or sepia color before hand-coloring to heighten the warm, nostalgic mood. See pages 45 to 49, for staining ideas.

Abide, on page 131 in the Artists' Gallery, illustrates two other ways to facilitate an aged look on paper: The artist washed photocopies of the building with thin acrylic paint and used tan cardstock to make the copy of the two boys.

Before

Original glossy lab-processed photograph

After

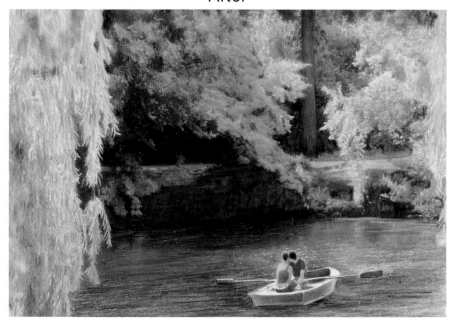

Finished in colored pencils

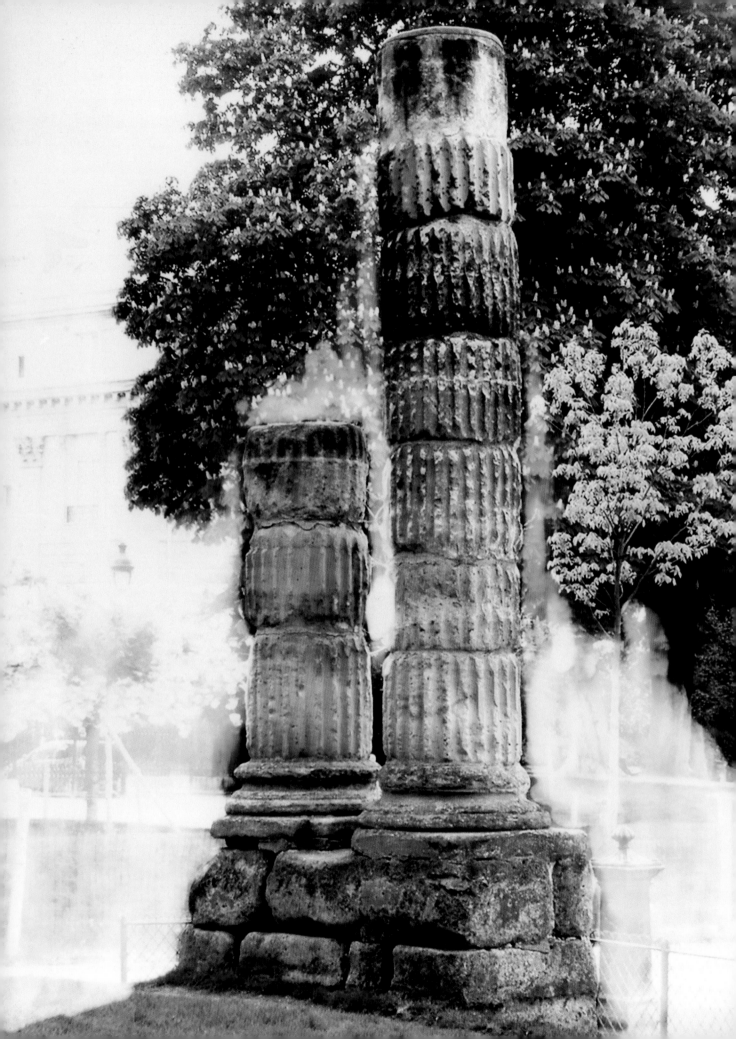

reach for the bleach

Alter dark areas of not-so-perfect photos the easy way with bleached lines or shapes!

Use bleach in a well-ventilated room. It can burn, so wear rubber gloves and protective clothing. There's less danger to the eyes when using a gel bleach pen rather than liquid bleach, but we advise safety glasses. And keep bleach out of the range of children and pets.

materials and tools

plastic sheeting

photo (inkjet or a chemically processed print)

rubber gloves, safety glasses, and protective clothing

bleach pen or liquid laundry bleach in container

synthetic paintbrushes or cotton swabs (optional)

photo tray or large, shallow container (optional)

resist material (optional)

water

damp paper towels

Applying Bleach

1 Protect the work area with a plastic covering.

2 If using liquid laundry bleach, dilute it by 50 percent with water.

3 Apply bleach selectively with cotton swabs for effective accents in contrast with dark backgrounds. Or lift the color from entire backgrounds if they're too "busy."

Bleach works quickly, although some papers and pigments are resistant to it, especially to gel bleach. Inkjet prints in particular may require more time to lighten.

4 When the bleach has worked its magic, swipe it off with a quick lifting motion of a damp paper towel. Then use another clean damp paper towel, removing all bleach thoroughly. Be careful not to smear an inkjet print. (It's okay to immerse lab-processed photos in a running water rinse.)

5 When the photo surface is dry, add new color to the bleached areas if desired. See pages 11 to 37 for ideas.

While reds, yellows, and oranges often result when bleaching darkroom- or lab-processed prints, inkjet prints may lighten to lovely turquoise colors as shown here. Effects will vary.

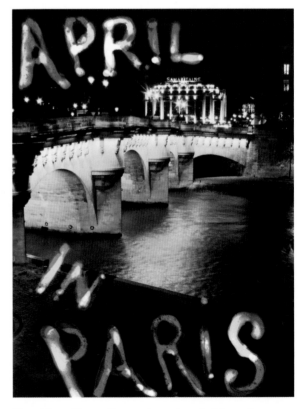

Bleaching with a cotton swab produced white, yellow, even red-orange in the words on this lab-processed snapshot.

Pointers from Paula

Try bathing an entire lab-processed photo in a tray of bleach/water solution. Again, use half water and half liquid laundry bleach. Immerse the color print briefly. As soon as colors just begin to change to reds, magentas, even yellows, remove from tray. Rinse immediately in running water.

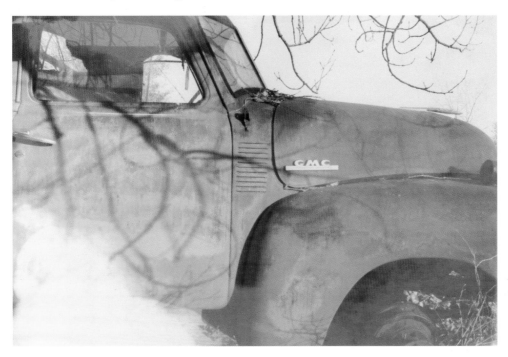

A bleach-solution bath has affected the colors in this snapshot.

Repelling Bleach

Rubber cement and artists' masking fluid are resist materials that work well to repel bleach. Another medium—wax crayon—also withstands bleach. Before bleaching the photo, apply a heavy, waxy coat over any area to be preserved.

In this example, rubber cement masked the areas of the photo I wanted to preserve. Bleaching removed the rest of the photo.

An immersion in bleach solution, then a chop session and re-assemblage—whew! This photo, rearranged and re-photographed, has an entirely new appearance.

Before

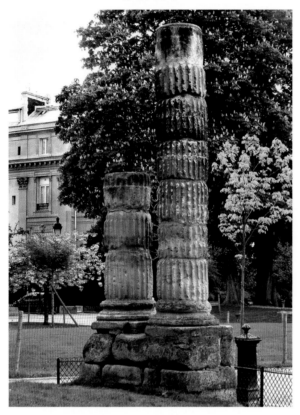

The fencing, water fountain, etc., lessen the power of these columns.

After

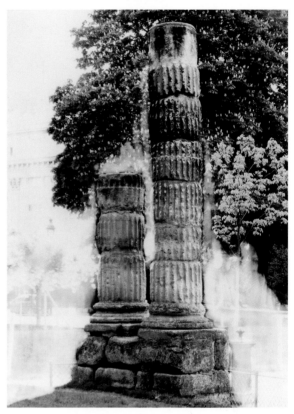

Masking the columns and bleaching the background of this inkjet print strengthens the overall impact.

pleasing tones

Staining and dyeing prints is as fun and easy as coloring Easter eggs!

Toning black and white photographs is a long-established practice, yet the staining agents discussed in this chapter yield great results on some color prints, too. Effects can be flamboyant or subtle, and results will vary.

materials and tools

plastic sheeting and protective clothing

photograph (use a chemically processed photo or a silver-based print for the immersion method)

tinting medium

tongs and/or rubber gloves

shallow tray or pan

water

brushes or cotton swabs (optional)

Frisket or other resist material (optional)

UV-filtering spray (optional)

pleasing tones (continued)

After Dyeing

1 Remove the print from the tray and rinse in cool water until it runs clear.

2 Dry the print thoroughly. If you've used a mask, peel it off or apply more Frisket elsewhere and dye the photo in yet another color!

3 Finally, spray with a lacquer protectant if desired. Food coloring and several other tinting agents are not lightfast, so a UV-shielding spray is a good idea.

This black and white enlargement on resin-coated paper acquired more interest through strong tea (bags and instant).

A white sky in the original photo lent itself to dyeing. Orange powdered fabric dye (Dylon, mixed with warm water) converts this lab-processed print into a showy example.

Fabric dye adds warmth to a photo enlarged on resin-coated paper.

Before

After

Before staining, this lab-processed color print was neutral and colorless.

Tea dyed the emulsion in a few places. Then, with the photo in a pan of shallow water, the artist dropped blue food coloring into several areas.

grant an extension

Ever feel fenced in? Or boxed in? Think outside the box!
What's to be found just out of the camera's range?

Extending part of a photo beyond its edge is an arty, imaginative tactic. In the photo at left, acrylic paints extend a snapshot adhered to a canvas panel.

materials and tools

borderless photograph

adhesive

matboard or other sturdy support, larger than the image

pencils, pens, paints, pastels, markers

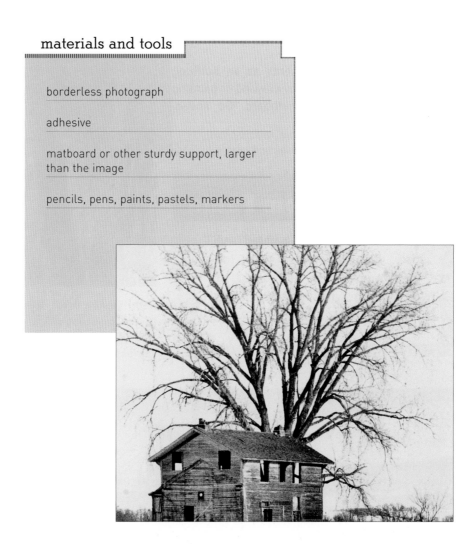

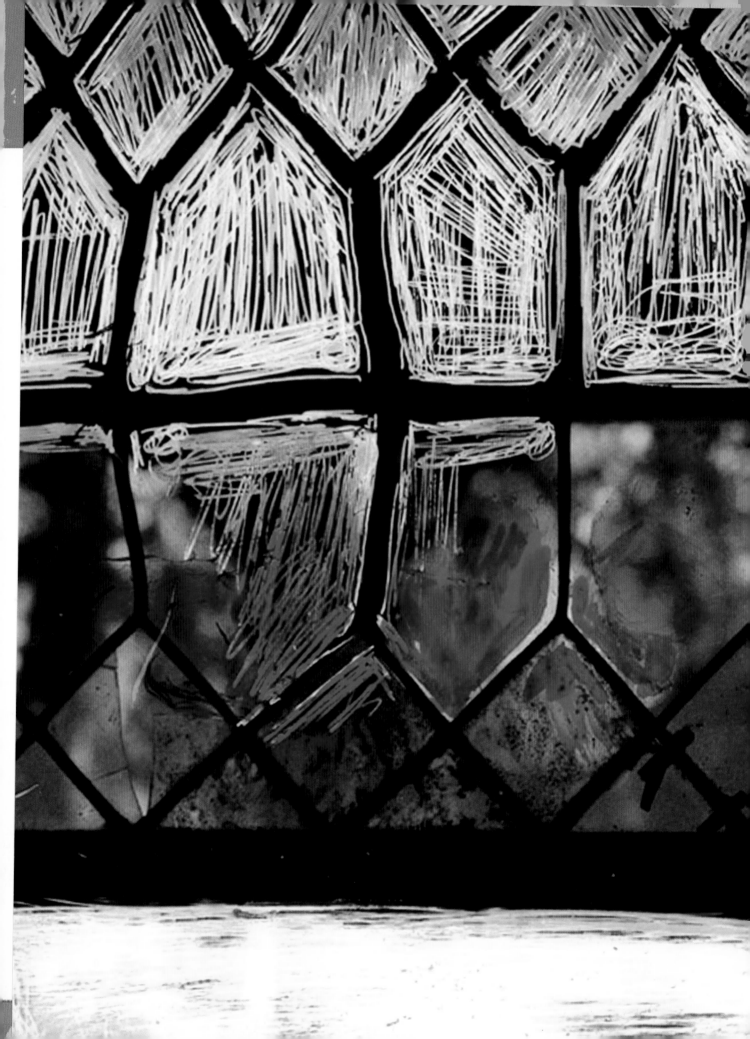

scratch that!

Sgraffito is an art term for the technique of incising a surface to reveal another color underneath.

Don't be afraid to "deface" a dim photograph (or a spare) with sandpaper or a pointed tool. Abrading the emulsion will add texture and variety, and impart a pleasing, aged look. And scratched-in lines can add sharpness, literally!

materials and tools

photograph (lab- or darkroom-processed)

tray of warm water

scratch tool (see page 56)

sandpaper, fine- to medium-grit

paper towel

inks or markers (optional)

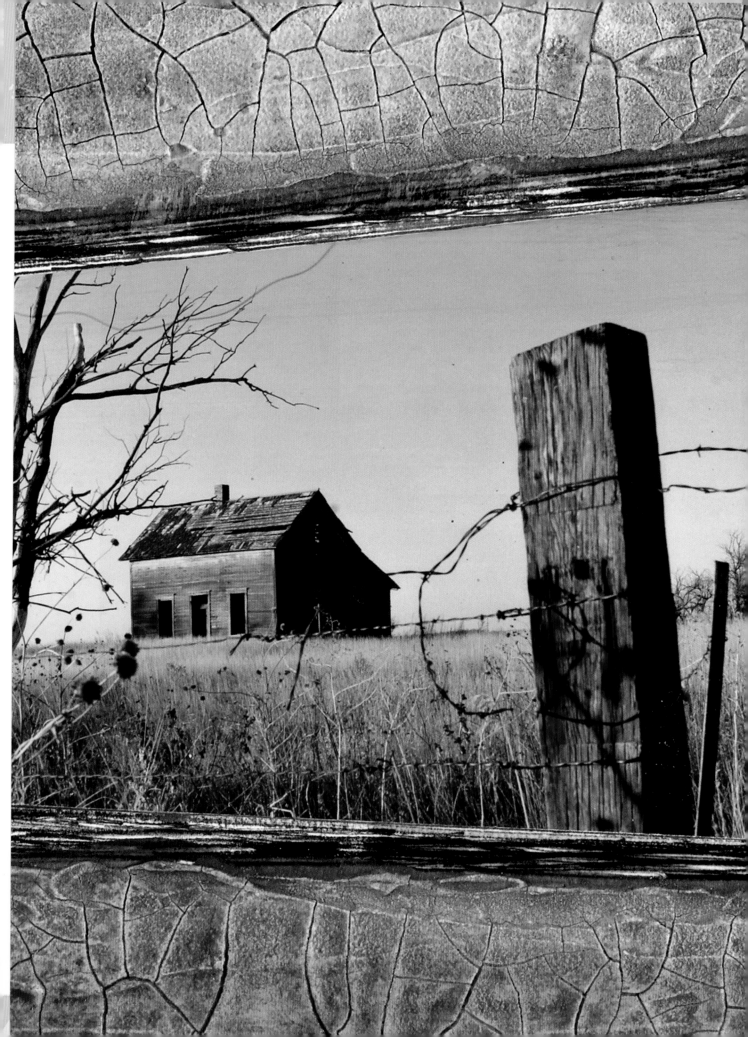

surrounded with ingenuity

Hand-draw your own decorative edging around a mounted photograph. It's a frame-up you'll enjoy!

A creative border adds just the right touch to a special photo. You don't have to be a trained artist—it's better that your design shows the mark of its maker. Let the photo inspire you.

materials and tools

borderless photograph

pencils, pens, or markers

matboard, tagboard, or illustration board

adhesive

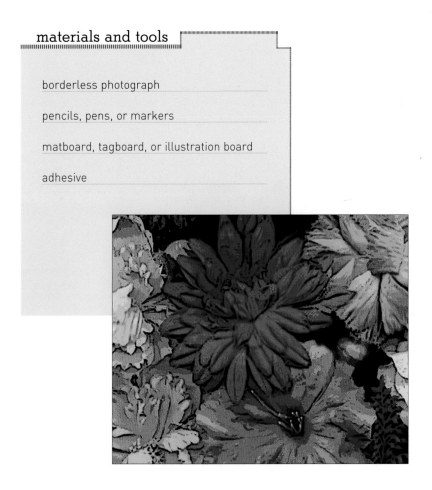

Beautifying with a Border

1 Mount the photo onto a white or light-colored background, leaving a wide margin.

2 Draw an ornate "frame" around the photograph, working directly on the matboard with pencils, pens, or markers. Use lines, shapes, and colors appropriate to the subject matter. Make the edging as elaborate as desired.

Pointers from Paula

Feel free to break away from the rectangular shape. The drawn-on frame can be circular, oval, or triangular instead, as can the photo itself. Or let your creativity run wild and design an irregular, free-form border!

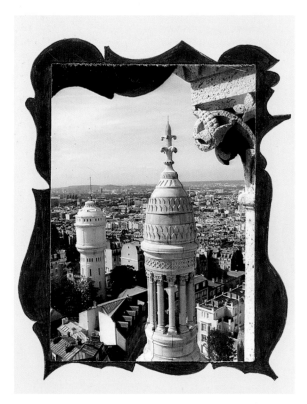

This decorative edging (in black felt pen) seems fitting for the subject.

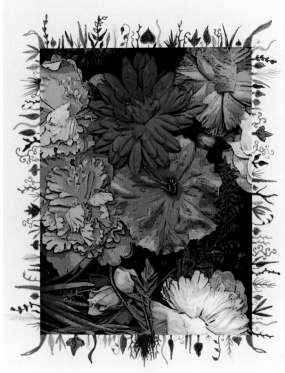

Fine-line markers are just the thing for drawing ornate borders, but do try a variety of thick and thin pen tips.

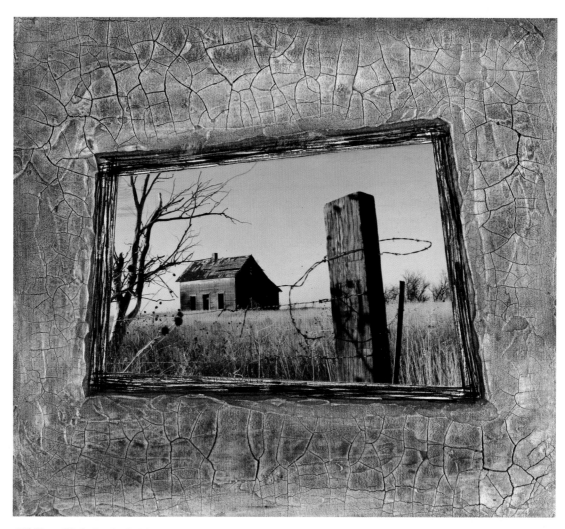

Old Home Week, Paula Guhin. Abandoned houses call to me to preserve them on film. Fine black marker lines edge this trapezoidal snapshot. Crackle paste "antiqued" with thin acrylic paint surrounds all.

An Ir-resist-ible Idea

1 Select a magazine page to alter. Images with mostly light or bright colors work the best.

2 Apply the resist medium of choice: wax (crayon, paraffin, or candle wax), rubber cement, or art masking fluid. Fill in shapes, draw new lines, and/or write words, covering important elements that you wish to preserve.

Removable artists' liquid masking fluid is not recommended for soft sized papers. Do not leave it on any photo for long periods of time.

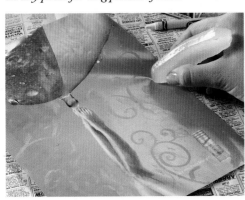

3 Press heavily if using wax. It's difficult to see "clear" wax on the page, so check your progress by tilting the paper toward a light source occasionally. When finished, go directly to the next step.

If using art masking fluid or rubber cement, allow to dry thoroughly before proceeding.

4 Apply the ink with broad, gentle strokes of the brush. Don't scrub. Allow the ink to dry.

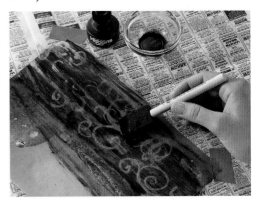

5 Wax does not require removal from the page after the ink has dried, but do rub off rubber cement or masking fluid with fingers or an eraser.

Pointers from Paula

Ink might bead up on some glossy or slick magazine papers. If droplets and streaks occur, try two light coats of ink in different directions, allowing the first to dry before applying the second.

Some brands of rubber cement come with their own applicator brush in the lid. Remove rubber cement or dried Frisket from your own brushes with turpentine or other solvent.

Pointers from Paula

Thin magazine pages will buckle and curl, so tape their edges down before covering them with India ink. When dry, remove rubbery masking material and iron the paper flat or press with heavy books on top.

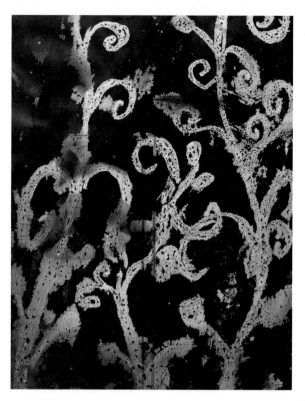

Flamboyant foliage (drawn with white crayon) seems to "pop" after the application of India ink to the magazine page.

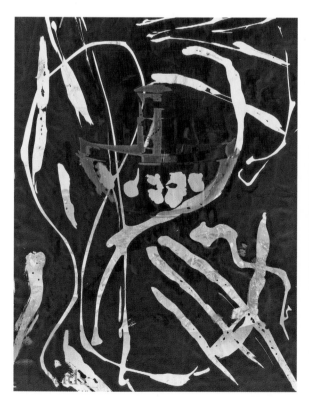

Rubber cement allowed the pale colors to show through here. Just as brights do, pastels contrast well with black.

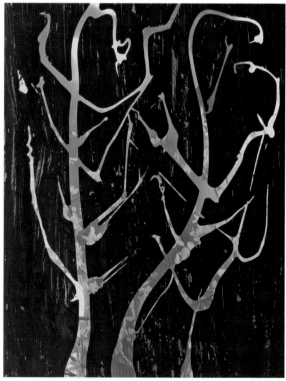

The twig shapes here were created with rubber cement.

Be a Real Cut-up

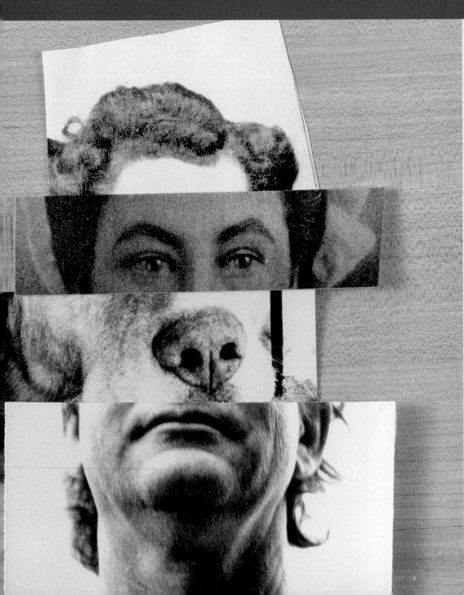

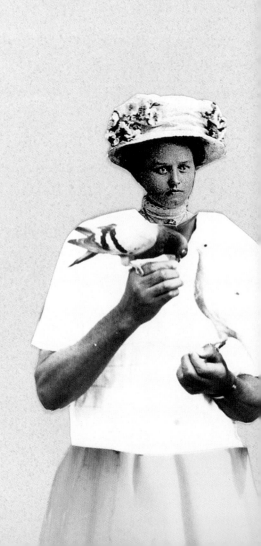

texture/pattern patchwork

Make a "quilt" of harmonious colors, spotlighting textures, motifs, or a particular theme.

Repetition of some colors, patterns, and/or textures will create a unified look to the design. Photographs you thought were useless or uninteresting can have new life with this technique.

materials and tools

a number of photographs

scissors and/or craft knife and cutting mat

matboard

adhesive

ruler (optional)

tagboard pattern (optional)

1 Use flawed photos, extra prints, even magazine pictures. Limit yourself to a palette of several colors that are pleasant together.

2 Find interesting patterns and textures to cut from any scrap pictures, or focus on a subject (a holiday, for example) and only use photos on that topic.

Texture refers to the tactile, surface quality of an object. Sometimes, as in photographs, texture is implied (perceived visually). Pattern is an arranged repetition of lines, forms, or shapes.

3 From the photos, cut geometric shapes (squares, circles, triangles, rectangles) or free-form, organic shapes. For precision, trace around a sturdy pattern if desired.

4 Arrange and rearrange the parts until satisfied with the whole. The entire artwork might be either symmetrical or irregular.

5 Fit the shapes together snugly, like puzzle pieces, and glue them to the matboard. Or overlap the pieces, glue them down, and photograph the arrangement. That photograph, when printed, will have a smooth, level finish.

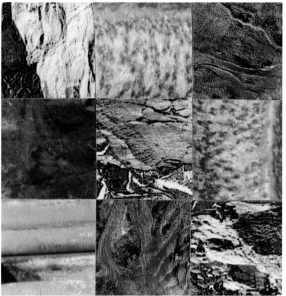

The use of mostly cool colors lends harmony to this geometric design.

Different parts of several photos recur here.

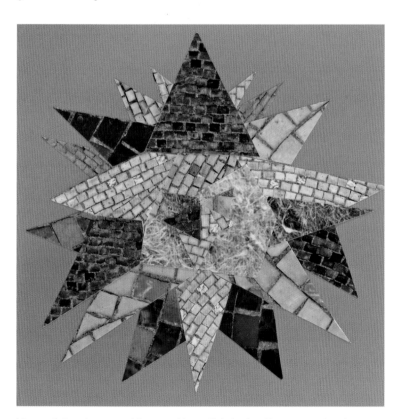

Many of the pieces making up this radial design lie atop each other.

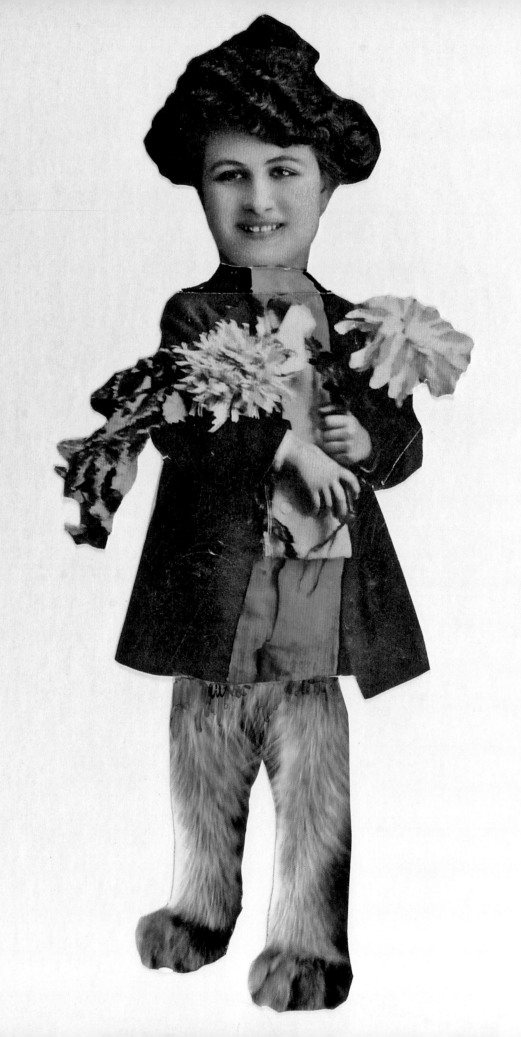

split personalities

With this playful project, the sum of the parts is a whole new person!

Sure, you can achieve similar results with some image-editing software. But creating with your hands instead of a mouse is immediate, stress-free, and fun!

materials and tools

multiple dispensable photographs

scissors and/or craft knife and cutting mat

matboard

adhesive

ruler (optional)

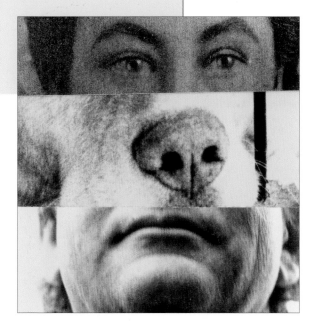

Mix 'n' Match

1 Gather spare photos (or copies) of people, or ask friends and family to pose for portraits. Photograph the entire figure or from the shoulders up. Take some pictures closer than others. Even magazine pictures work for this activity.

2 Select three separate photos of different people—young, old, male, female—the more diverse the better. Use either all color or all black and white photos for a better "fool the eye" effect.

3 Slice all three pictures horizontally into inexact thirds. Shuffle the pieces and combine them in funny new ways. Create a composite of one person's head, another's torso, and yet another's legs and feet. Check out the effect of different combinations before proceeding.

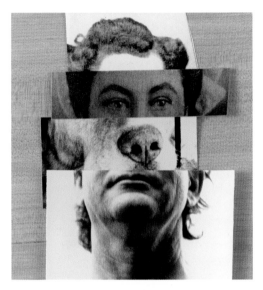

These loose parts (including a dog's nose!) have yet to be clipped around their edges.

4 Cut out the parts from the background of each photo. Before gluing down a witty combo, unify the parts by trimming their sides to adjoin evenly.

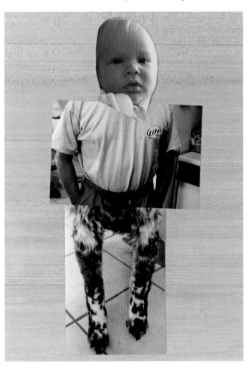

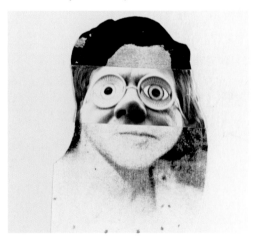

This merger is composed of one person's forehead, another's "eyes" and nose, and a third person's mouth and chin. Note how the trimmed edges blend together smoothly.

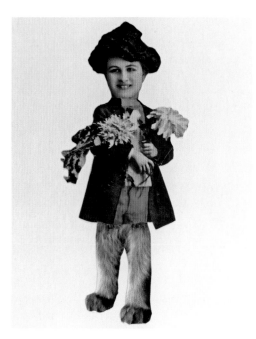

Animal photos mingle very well with people pictures.

5 Feel free to merge edges with ink pen, paintbrush, or other art tools, as shown here at the shoulders.

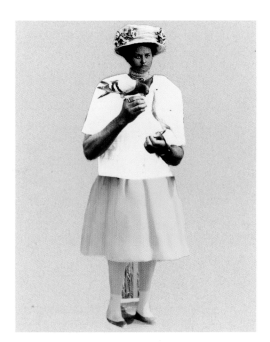

Even pictures of statues, like the hips and legs here, work with this activity.

Three members of one family contributed to this fusion.

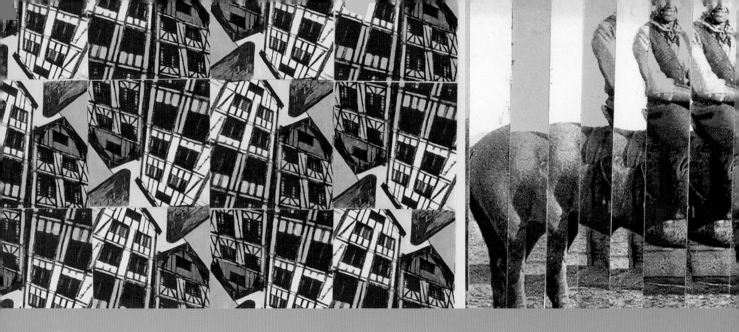

Creativity with Copiers

& Computers

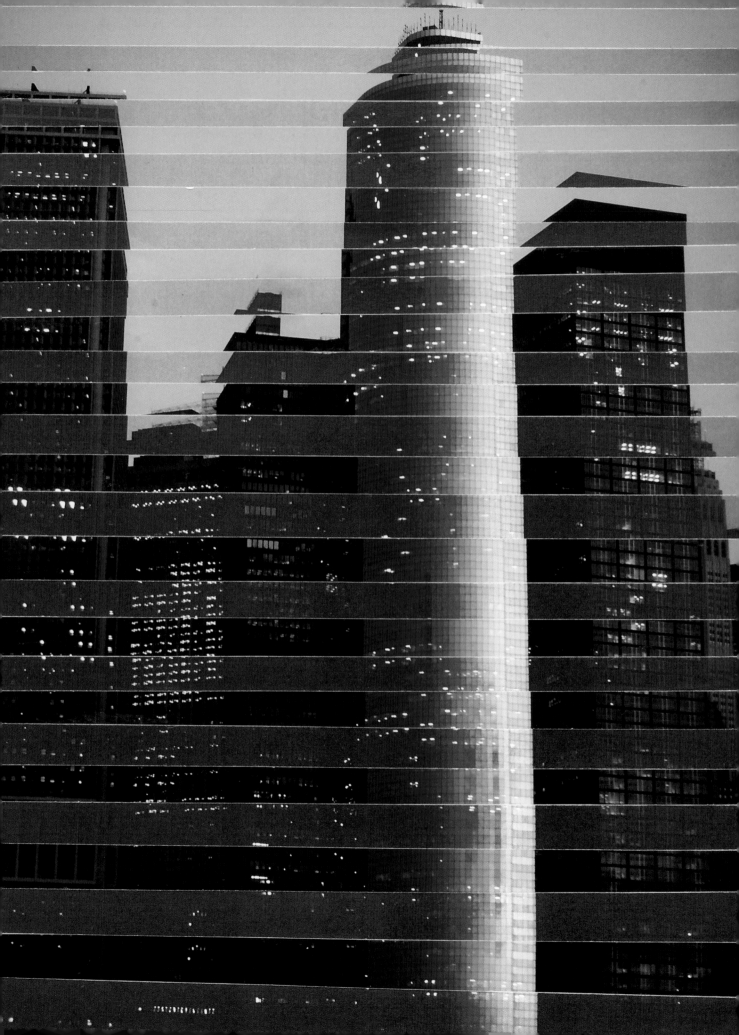

slice 'n' stretch

Want to capture a sense of movement in a photograph?

Shake things up a bit by combining two images that are identical or nearly so. Use a photocopier or print out two computer copies. The variety of copy papers, cardstock, and printer papers is amazing. The color selection alone is incredible!

materials and tools

borderless photo, two copies

trimmer, paper cutter, or ruler, craft knife, and cutting mat

adhesive

large piece of matboard

Double the Fun

1 This rhythmic treatment will produce a pulsating impression of motion, so select a photo that suggests energy and animation.

2 Make a duplicate the same size or find a nearly identical print the same size.

Pointers from Paula

Tone one of the copies slightly lighter or darker than the other, if desired, to increase the vitality of the finished work.

3 Choose a mounting board. It must be much larger than the prints, because the size of the image will be almost doubled when the work is finished.

4 Decide in which direction to stretch the image (vertically, horizontally, or diagonally). Do you wish to elongate the picture up and down or to widen it? Clip the two copies together securely and cut a strip about ⅜" (1 cm) wide from both at the same time, and in the same direction.

5 Continue cutting strips in the same direction, and lay them down in order on the matboard. Vary the width of the strips if you wish.

6 Nudge the slices as needed to better align the main subject of the photo. If necessary, discard a few strips to improve the harmony of the whole.

7 When finished cutting strips, trim the jagged edges, if desired, or leave them serrated. Then glue down all the pieces.

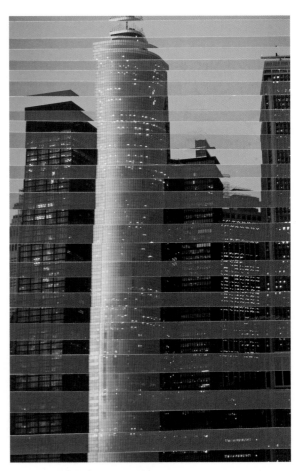

Horizontal strips from a glossy photo contrast with strips from a matte cardstock copy.

Before

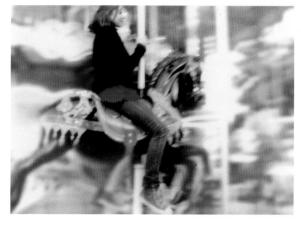

Girl on merry-go-round before stretching with strips from a duplicate

After

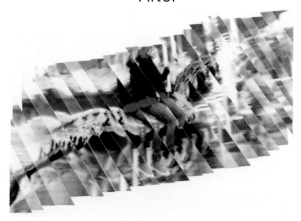

This is a result of cutting at a slant. The jagged edges echo the feeling of motion.

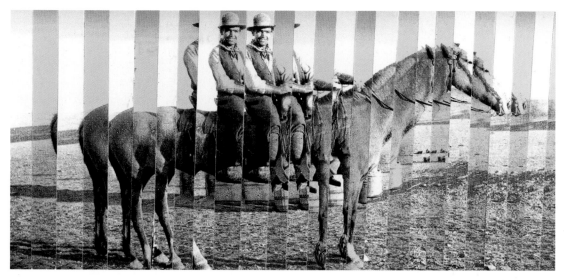

Cutting vertically yields a wider composite.

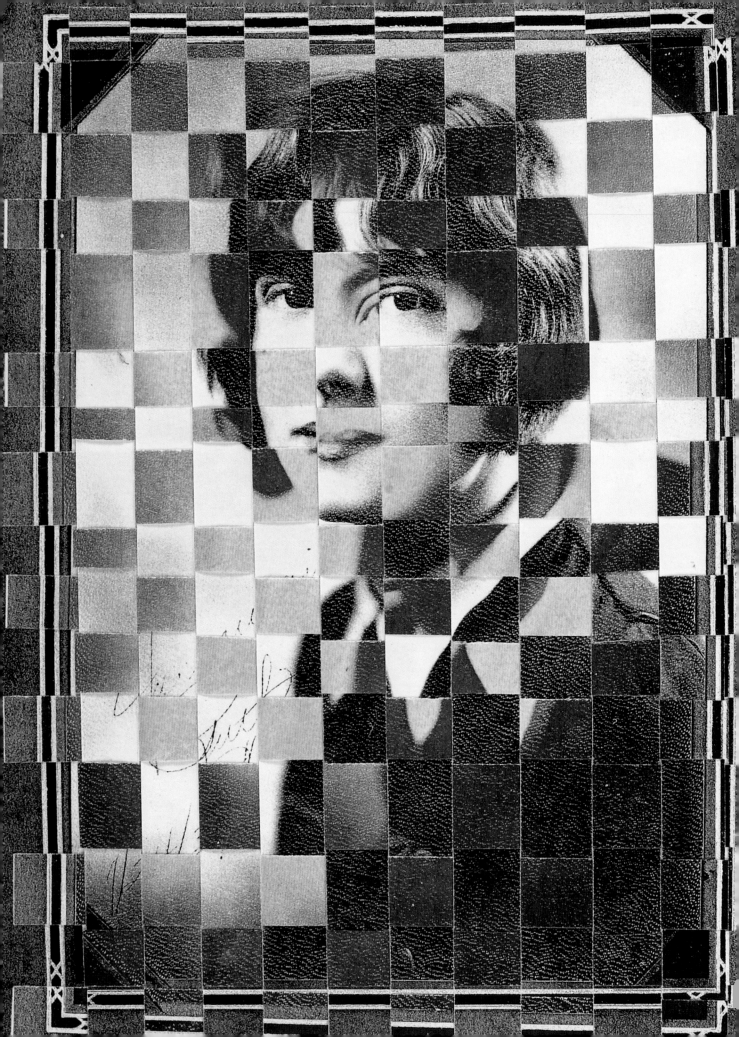

leave it to weaving

Whether it's simple and straightforward or something else entirely, weaving is a wonderful way to design with distinction.

One photo printed twice can form both the warp and the weft. Or choose one photo for the warp and a compatible photo for the weft.

materials and tools

borderless photo, two copies

pencil

ruler

scissors or craft knife and cutting mat

adhesive

paper trimmer or cutter and cutting mat (optional)

matboard (optional)

Be a Dream Weaver

1 Use two same-sized photographs, identical or compatible. If paper weaving for the first time, choose sturdy papers and don't work too small. If one copy is colored differently from the other, the weave pattern will be enhanced.

2 In weaving, the term for the materials running lengthwise (up and down) is the warp. In paper weaving, one sheet can become both the warp and the loom itself. First, on the back of that page, draw a pencil line straight across near the top, about ½" (1.3 cm) down.

3 From the bottom of that same page, cut slits upward to the pencil line, about ½" (1.3 cm) apart. The cuts need not be straight—try curvy or zigzag if desired!

Another method for creating a paper loom is to fold the sheet in half horizontally, draw a pencil line about ½" (1.3 cm) from the open end to limit the cutting, and (from the fold) cut up to that line.

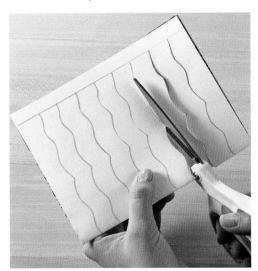

4 Cut the second photograph into strips all the way across the sheet, working horizontally this time. The term for these pieces is the weft. Lay the strips out in order.

5 Starting at one side of the warp, slide the first strip over and under the loom strips consecutively, repeating the over and under pattern all the way to the other side.

6 With the second weft strip, ensure that it goes under the warp where the first is over it. Continue weaving the second row in an under–over pattern. The artwork should begin to look like a checkerboard.

7 Finger-comb the strips upward to tighten the weaving.

8 Repeat the technique used in rows one and two until the loom is full. Discard some strips as necessary.

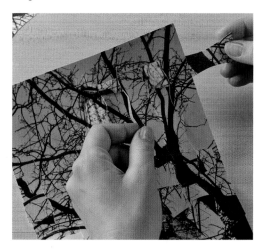

Finishing the Weaving

Glue all the tabs down at the edges, front, and back, if desired. To stabilize a loose weave, apply clear packing tape to the back or glue the entire weaving to a piece of matboard.

Endless Possibilities

Vary the widths of the strips, try a black and white copy with a color photo, or weave two different, unrelated images together. Weave selectively and leave other areas untouched. Give magazine papers, wallpapers, and colorful wrapping papers a go. Interweave yarn, ribbon, or metallic thread. Tear strips rather than cutting them. Let your imagination run riot!

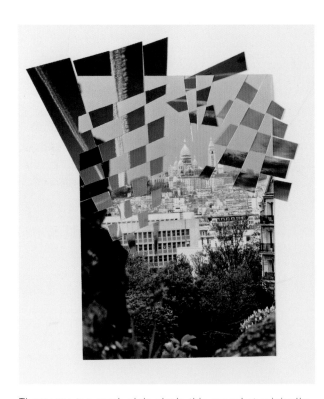

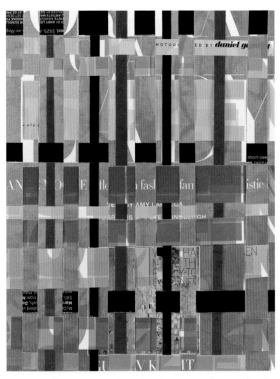

There was too much plain sky in this snapshot originally. Jet trails and clouds from other photos augment it.

Over-weaving with thin strips adds interest to this example done in magazine papers.

Before

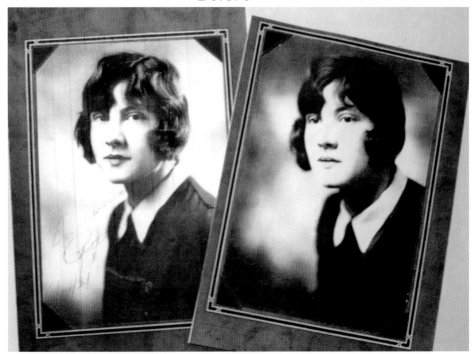

Two very similar portraits of the same woman.

After

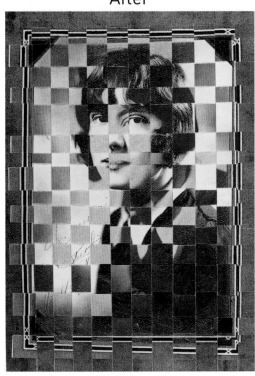

Weaving provides a pleasing texture. One of the two photocopies woven together has a tint, achieved with chalk pastel.

Go Forth and Multiply

1 Select a photograph with notable visual impact and distinct lights and darks.

2 Crop the image to a square format and, if necessary, reduce the size. The kaleidoscope will be most successful if parts of the image extend to the edges of the square.

3 Photocopy the square four to twelve times. Or use image-editing software to create a repetitive photographic pattern, even mirroring (flipping) half the squares if desired.

4 Cut out the copied or printed squares and begin arranging them in rows on the matboard so that they touch each other. Experiment by rotating the pieces, alternating their directions in various combinations until you find the most pleasing recurring design.

5 Adhere the squares to the matboard. Add color uniformly to each with pencils or markers if desired. Re-photograph the finished work if you wish to meld the units into a smooth-surfaced whole.

Pointers from Paula

Copies on cardstock or sturdy photo paper are easy to work with. A glue stick is a convenient adhesive for this project.

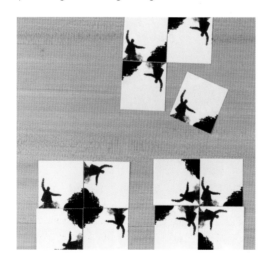

Before

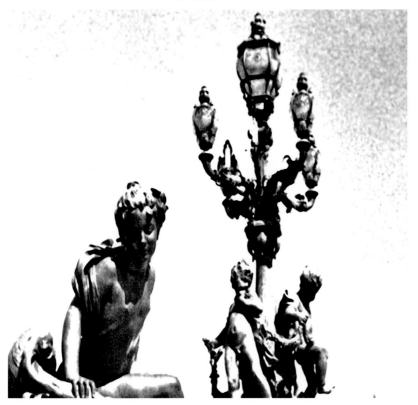

The original, high-contrast photograph

After

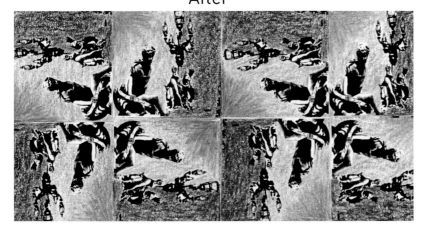

The statue and lamp-post photo has become an abstract design enhanced with colored pencils.

kool kaleidoscopes (continued)

Before

A rooftop and
ionic column

After

Bright markers
enhance black and
white copies.

Branching Out has a graphic effect without the addition of color.

A door-knocker image cropped in half becomes an abstract design of curvy and straight lines.

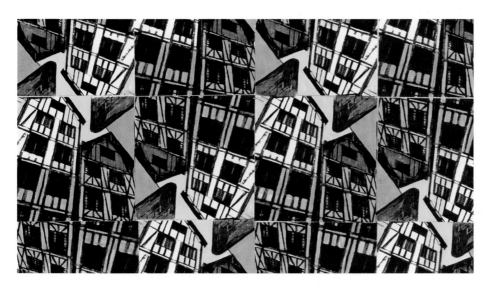

Highlighter markers impart extra punch to this design based on a picture of two buildings.

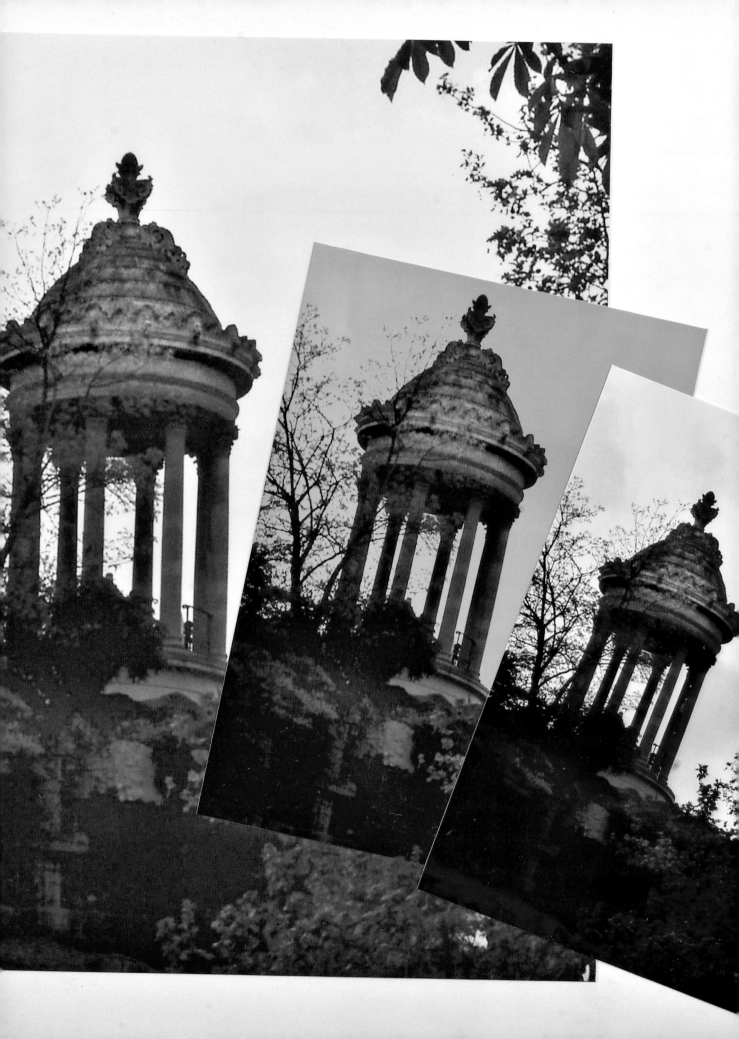

consecutive copies

Stylizing with successive sizes is a snap, and the result can be a dynamic design. Three is better than one!

The choice of subject matter will greatly influence the finished product's appeal. Use trial and error to learn which image is most eye-catching with this project.

materials and tools

three copies of a borderless photo (size small, medium, and large)

trimmer, paper cutter, or scissors

adhesive

large piece of matboard (optional)

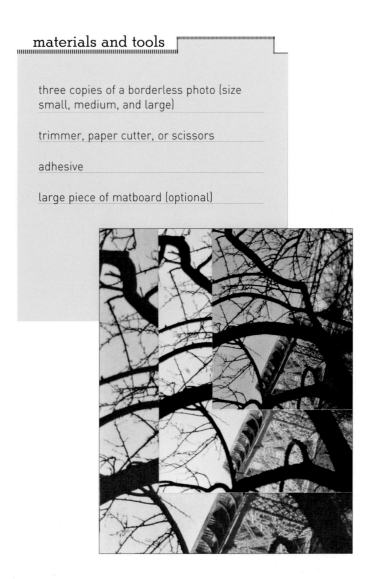

In Triplicate

1 Photocopy one image three times, progressively enlarging or reducing it. (Or accomplish the entire activity on the computer!) Make each copy lighter or darker than the last if desired. Here are three other ideas: print on three different colors of cardstock, progressively desaturate a color image, or dye the copies in varying tones.

2 Trim borders, if any, from the images. Rectangles aren't the only shape option, of course. Use any shape that works with the image.

3 Arrange the pieces with the largest first and the others atop it. Try out both an evenly balanced, formal design and an asymmetrical (off-center) one. Carry the layout off the top, bottom, or a side if desired.

4 When the most aesthetically pleasing arrangement is in place, glue the pieces down.

Pointers from Paula

Why settle for three images when you can have four or five? Put your own spin on things, as the example below demonstrates.

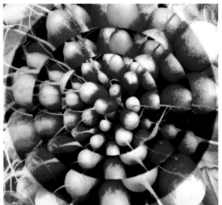

This composite is formally balanced.

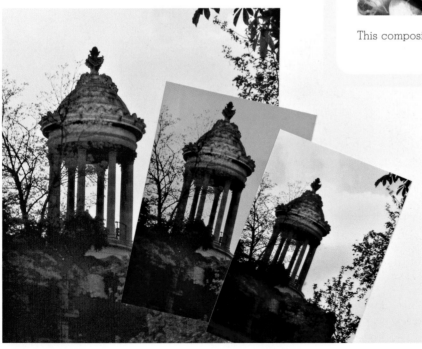

Here, a wash of red water-based ink lends a difference to the center image.

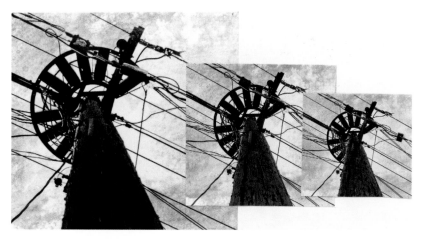

Colorize a black and white photo, if desired, before making color copies. Here, watercolor paints tint the original.

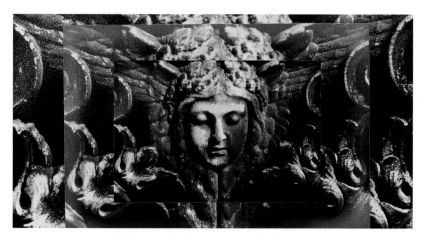

Repetition adds richness and complexity to the finished piece. Symmetrical compositions can impart strength and stability to artworks.

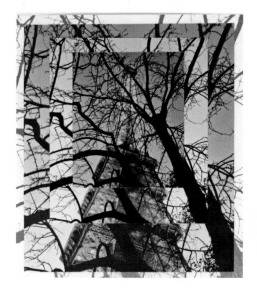

The largest piece, in faded black and white, becomes an understated background and border.

Here, the blacks and whites are inverted in alternate copies.

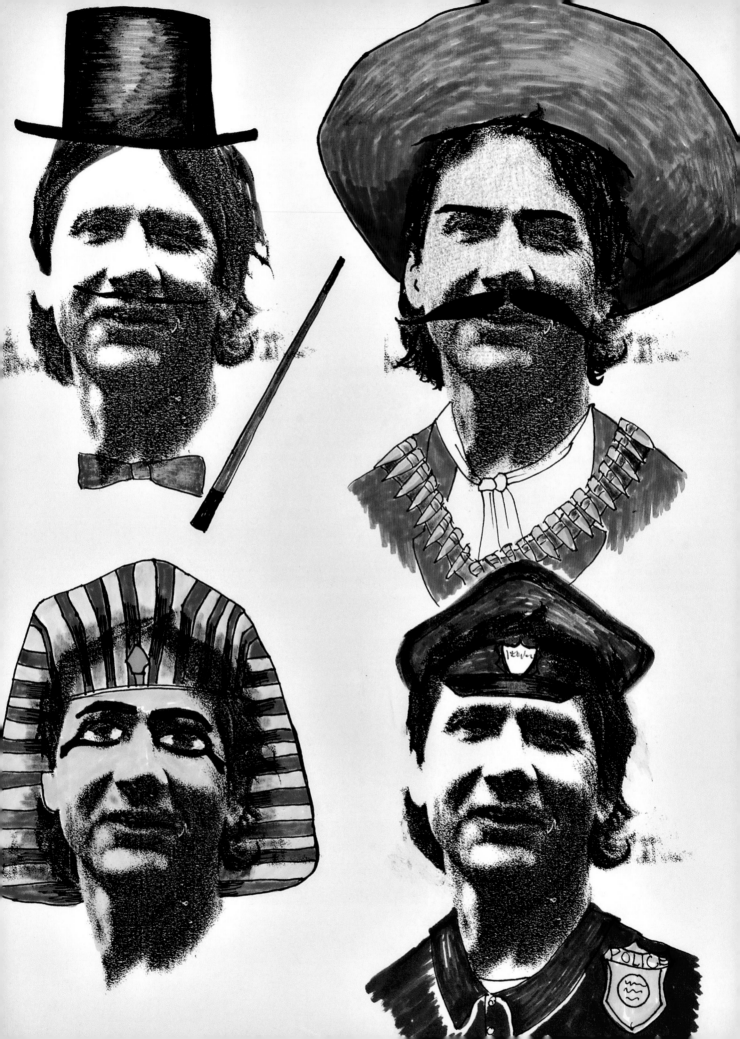

multifaceted personality

Help someone be all they can be—an entire cast of characters!

Select a head-and-shoulders shot in which the person is facing forward. Be certain that the individual will not mind being spoofed.

materials and tools

medium-sized photo of a person's head, copied four times or more

colored pencils or markers

paper cutter or scissors (optional)

metal ruler (optional)

adhesive (optional)

matboard (optional)

Using Your Head(s)

1 Photocopy the same picture multiple times, setting the machine to print lighter. Black and white copies that aren't too dark may be easier to alter than color clones.

2 With colored pencils or markers, depict each portrait differently, adding accessories and changing the features and clothing. Invent characters, perhaps illustrating existing behavioral qualities. Is she an angel at times? Does he prefer cats or dogs?

Typecasting

Here are some ideas to unleash your creative flow:

Cartoon character

Scary monster

Pirate

Superhero

Mummy

Vampire

Wizard

Royalty

Sherlock Holmes

Aviator

Soldier

Pointers from Paula

Cut and paste (with the computer or in the time-honored way) or photocopy separate duplicates onto a single, non-glossy page.

Some personas may require drastic changes, such as hair or eyeglasses removal. Use white correction fluid to cover dark areas as needed.

 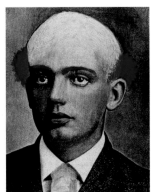

Whiting out the hair produces a major transformation. The finished makeover.

Before

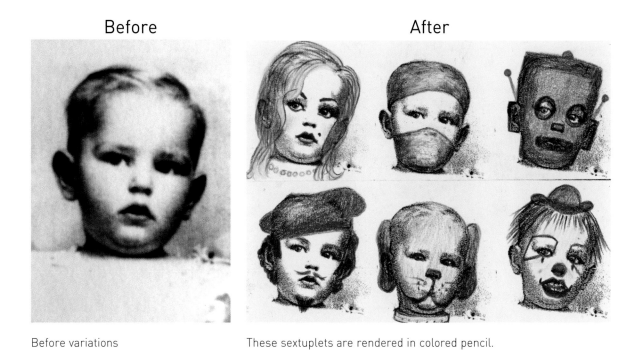

Before variations

After

These sextuplets are rendered in colored pencil.

Before

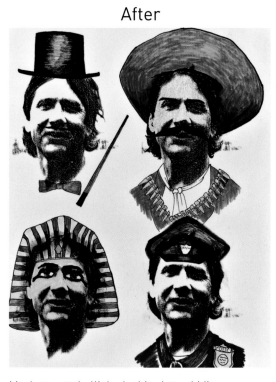

Before transformation

After

Markers embellished this law-abiding magic man interested in history.

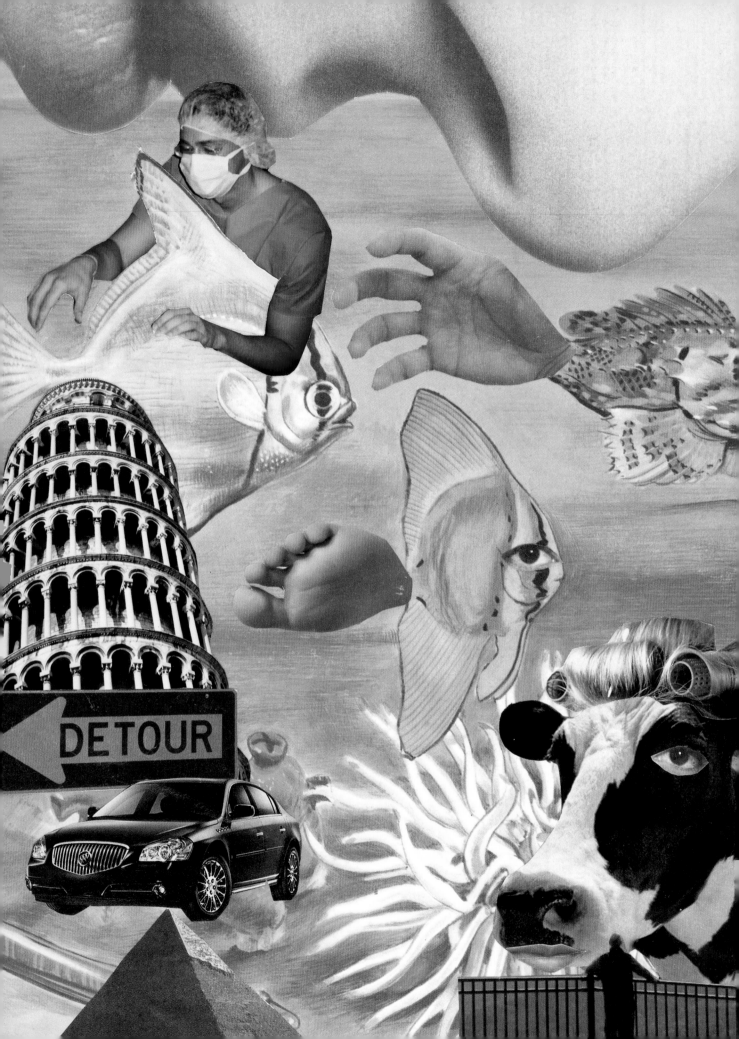

DETOUR

stir it up with surrealism

Discover the delight of montage and the fantasy of the absurd.

A montage is several different pictures super-imposed into a composite. Allow your cleverness to run amok with surrealism, an artistic movement embracing the fantastic and the dreamlike.

materials and tools

assorted spare photos

scissors and/or craft knife and cutting mat

adhesive

old magazines, catalogs, and cast-off picture books

matboard (optional)

markers or colored pencils (optional)

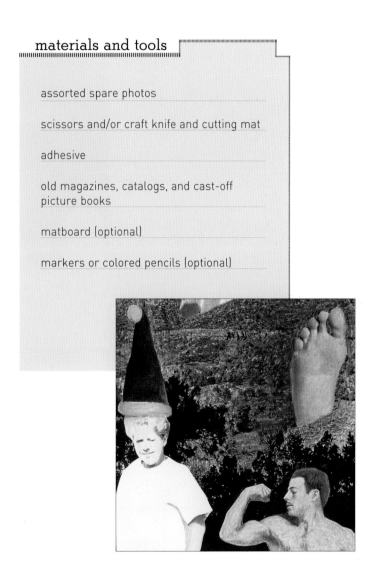

Getting Unreal

1 Select a mixed bag of photographs and other images of all sizes. Both color and black and white are okay.

2 For a background upon which to "build" the montage, use matboard or, better yet, a very large photo of a landscape or an interior.

3 Cut carefully around the contours of each element to be added to the setting. Merge people, objects, and animals into odd combinations. Change sizes and proportions at will.

4 Although surrealism is irrational and whimsical, do join parts of each unit together smoothly to become one. See the example below.

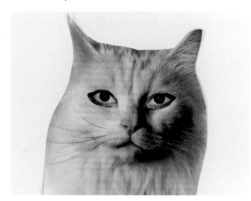

Here the added-on eyes almost seem to be an integral part of the cat's head.

5 Arrange the components on the background in inventive ways. Don't glue them down until satisfied with the entire layout.

6 The completed composite can be a finished artwork in itself—but wait, there's more! Photocopy it in black and white at a light setting. Use white cardstock if possible.

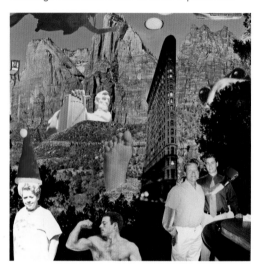

The background page of this montage is from an unwanted, oversized book about the Grand Canyon.

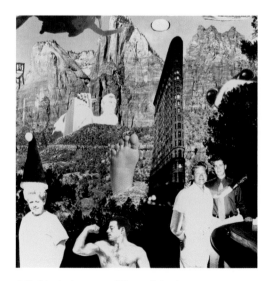

A light photocopy of the original

7 Apply unnatural colors to the copy with colored pencils or markers, if desired.

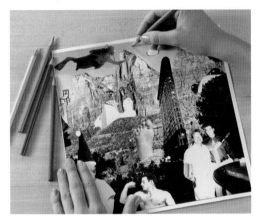

Green skies are odd indeed!

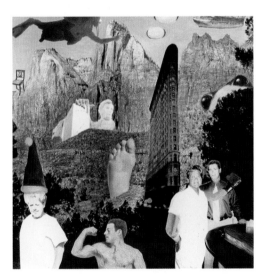

The completed *Strong Men*, hand-colored in weird hues

Pointers from Paula

Beginning with a big, built-in background scene is convenient. An 8" x 10" (20.3 x 25.4 cm) print of an underwater view, a large illustration of outer space from an old book—the more bizarre the better!

Certainly you can achieve surreal effects with digital images and photo-editing software, and can even alter the colors with the computer.

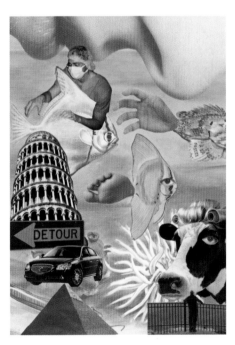

A cow under water? Yes, in the illogical world of surrealism.

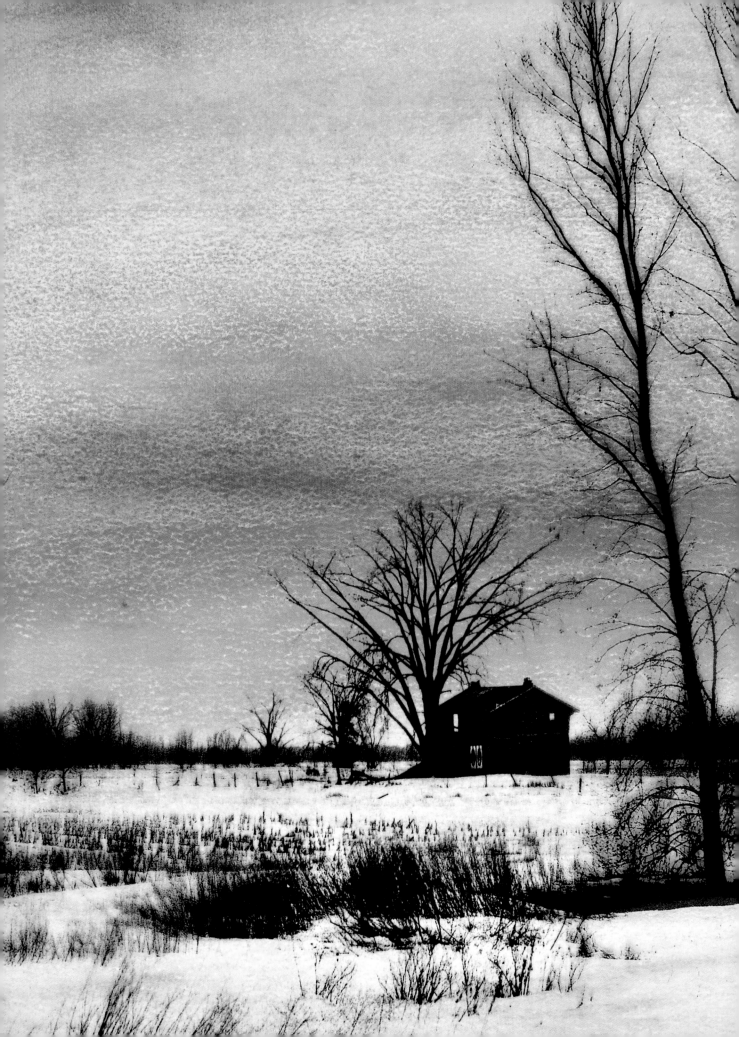

what lies beneath

Dress up the basic black of a transparency with bright, lovely color and more.

Select a photograph with many light or white areas. Avoid "busy" images—a simple photo will be better.

materials and tools

high-contrast photograph

transparency film, 8½" x 11" (21.6 x 27.9 cm)

copier or computer printer

watercolor paper or other heavy white paper

watercolors or acrylic paints (or chalk pastels)

paintbrushes

container of water

transparent tape or gel medium

matboard (optional)

tracing paper (optional)

what lies beneath (continued)

Under Construction

1 Enlarge the photo to 8" x 10" (20.3 x 25.4 cm).

2 Photocopy the image in black and white onto transparency film or print it out (again, black and white) on inkjet transparency film.

3 Pre-wet heavy watercolor paper if softly blended color is the desired effect. Float washes of light or bright paint onto the paper. Place the colors where they will best enhance the clear portions of the transparency. Use a larger brush to blend watercolors smoothly.

4 Allow the paint to dry thoroughly before attaching the transparency (emulsion/ink-side down) to the colored background. Making a "hinge" along the top of the two sheets with transparent tape is one method of joining the two pieces.

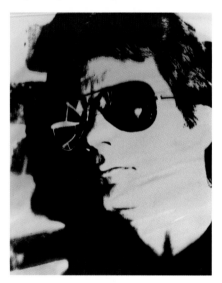

The "up" side of the transparency is the glossy side. The background's colors are watercolor paints.

Pointers from Paula

Remember to reverse the image before printing at home, especially if it includes text. Allow an inkjet print to dry thoroughly before handling the transparency.

Transparent tape can age badly. Other ways to secure the transparency to its colorful background include using brads or paper fasteners, or adhering it with a thin layer of gel medium.

Chalk Is Another Choice

Chalk pastels are a convenient substitute for paint. No brushes, no water, no fuss or muss!

Lay pastels in lightly at first onto sturdy white paper, and blend with fingers or tortillons. Spray with fixative and allow the spray to dry before attaching the transparency.

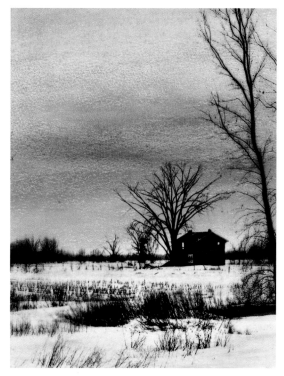

Vivid chalk pastels give this sunset a dramatic outcome.

what lies beneath (continued)

Alternatives Abound!

Rather than painting on paper, try gluing fabric, decorative papers, or wallpaper to matboard and then affixing a transparency atop it.

Another idea is to cut out paper pieces that correspond to various parts of the transparency, as shown below.

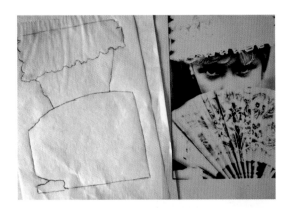

Outline shapes onto tracing paper and use as a cutting pattern (or, easier yet, put a paper copy of the image to the same purpose). From colored papers, cut out matching areas of flesh tones, clothing colors, grass, sky, and more.

Skin-colored paper, wallpaper, and a paper doily make up the backing. Always check the positioning of such shapes by overlaying the transparency before gluing down the paper pieces.

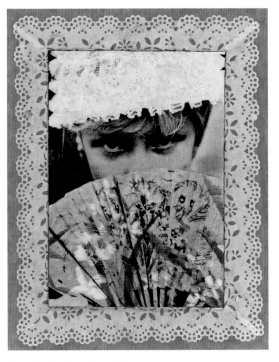

The finished *Girl with Fan*

Or Paint Directly on the Transparency!

Use acrylics on the clear portions of the emulsion side (the dull or rough side) for a stained-glass effect. No dark colors, please. Don't worry if a little paint dribbles onto the black ink or toner—it won't show on the front. Several coats of paint will help prevent streaks. Allow to dry between coats. Then flip the transparency over and mount it on matboard with the glossy side up.

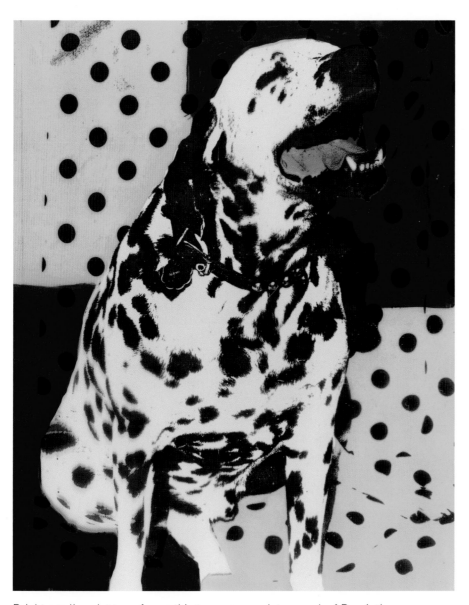

Bright acrylic paint transforms this transparency into a work of Pop Art!

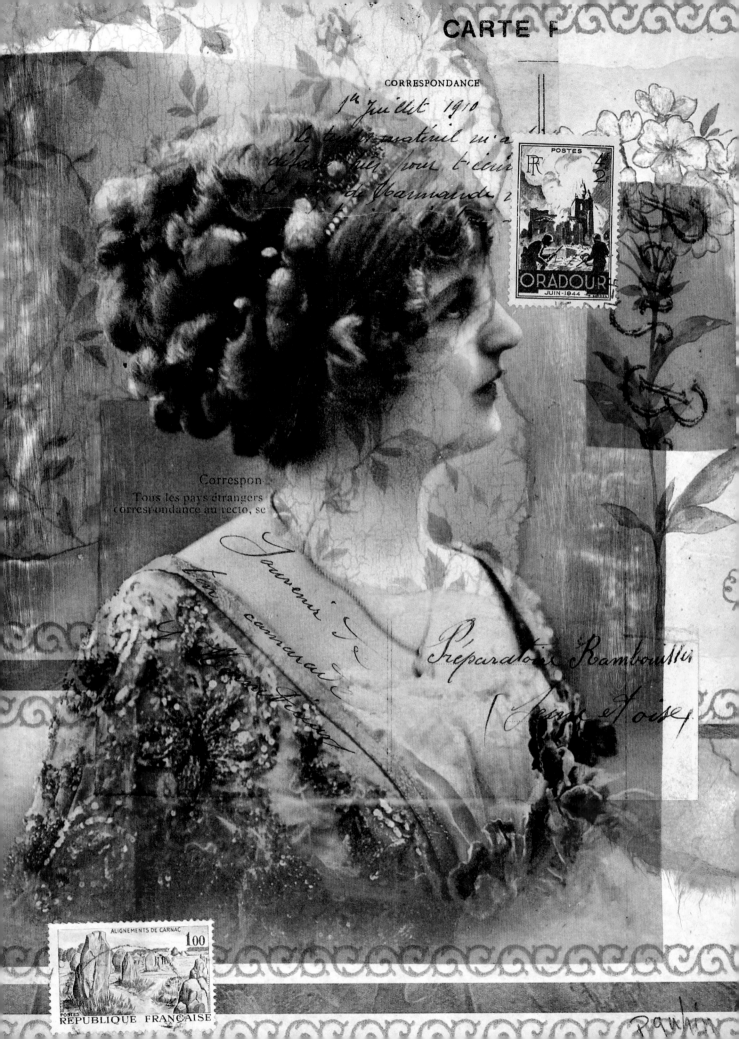

persona montage

Reinvent a portrait with a personalized, meaningful medley of words and images.

Find spare snapshots, a copy of a treasured letter, magazine papers, catalog pictures, poetry, maps, sheet music, greeting cards, and more.

materials and tools

high-contrast enlargement of someone's head and shoulders

transparency film, 8½" x 11" (21.6 x 27.9 cm)

acrylic gel medium

brush

ephemera such as postcards, postage stamps, sheet music, and maps

scissors and/or craft knife and cutting mat

matboard, white, 8½" x 11" (21.6 x 27.9 cm)

transparent tape (optional)

persona montage (continued)

All the Things You Are

1 Choose a portrait with plenty of white or light portions.

The original color photograph

2 Copy or print the portrait in black and white onto transparency film. Use a high-contrast setting.

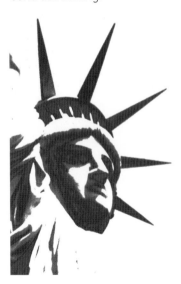

Statue, now in gray scale, is desaturated, brightened, and heightened in contrast.

3 Collect an assortment of papers and pictures expressive of the subject—representing his or her individuality. What's her preferred sport? His favorite food? Musician? Actor?

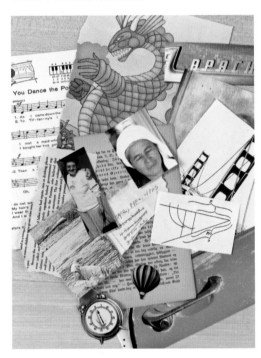

This memorabilia is typical of papers that might peek through parts of a transparency later.

4 Cut or tear around the edges of the pictures and papers. Try a variety of sizes and shapes. Fill the space on the matboard, overlapping and arranging the pieces so that light colors contrast with and best display the dark parts of the transparency. Test the effect with the transparency on top before gluing anything.

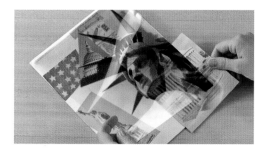

It's easy to flip this transparency into place (it's taped to the top edge of the matboard), to verify placement of photos and ephemera before gluing them down.

Pointers from Paula

Position the pieces in a vertical/horizontal composition or array them at angles. Turn some pieces on their sides or even upside down if desired.

5 When you're satisfied with the result, adhere the pieces to the matboard. Gel medium is an excellent adhesive.

6 When the background materials are flat and dry, attach the transparency with invisible tape if you haven't already done so. Or use a brush to apply a thin, even coat of gel medium to the entire montage/collage. Adhere the transparency (ink side down) and place a large, flat, heavy book on top while it dries.

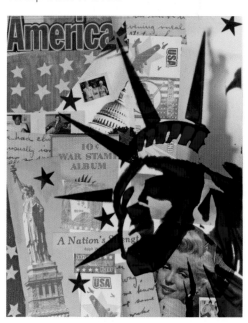

Foil stars complement the theme here. Consider capturing other flat objects beneath a transparency—a pressed flower or leaf, an old key, a feather, lace, or ribbon, for example.

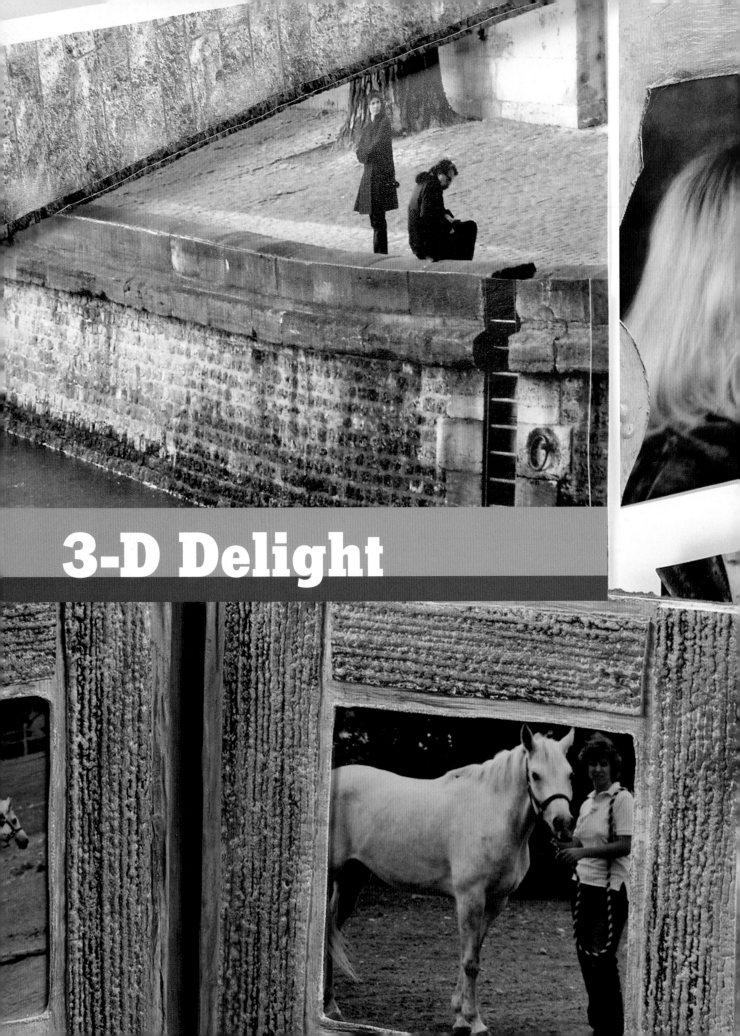

3-D Delight

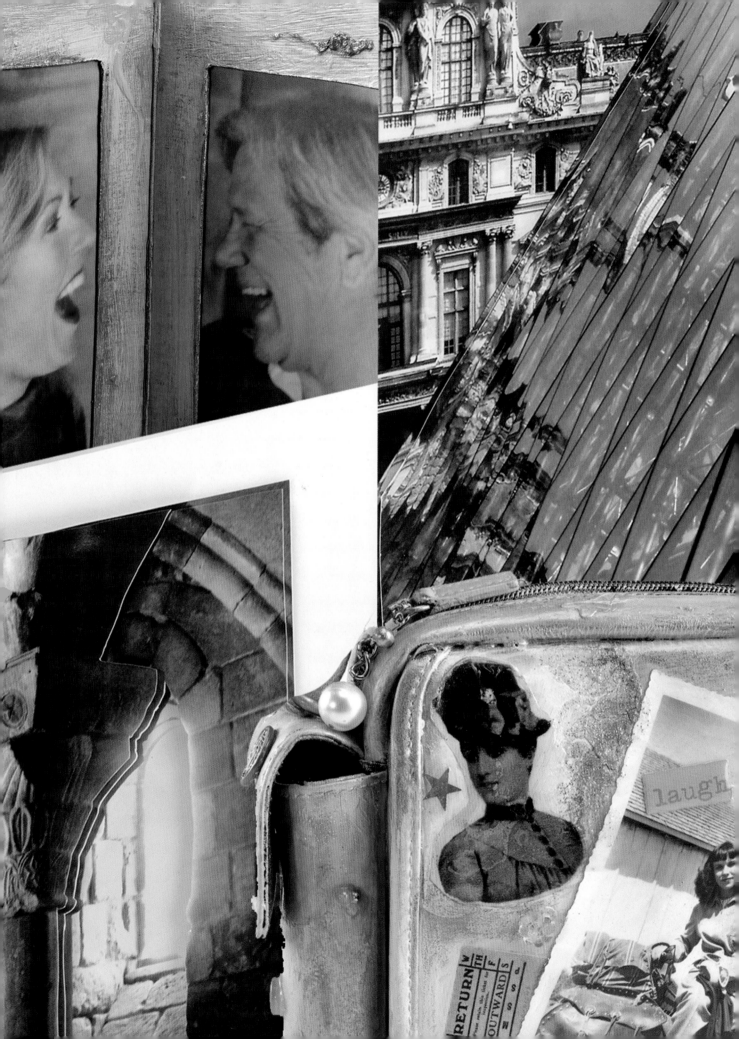

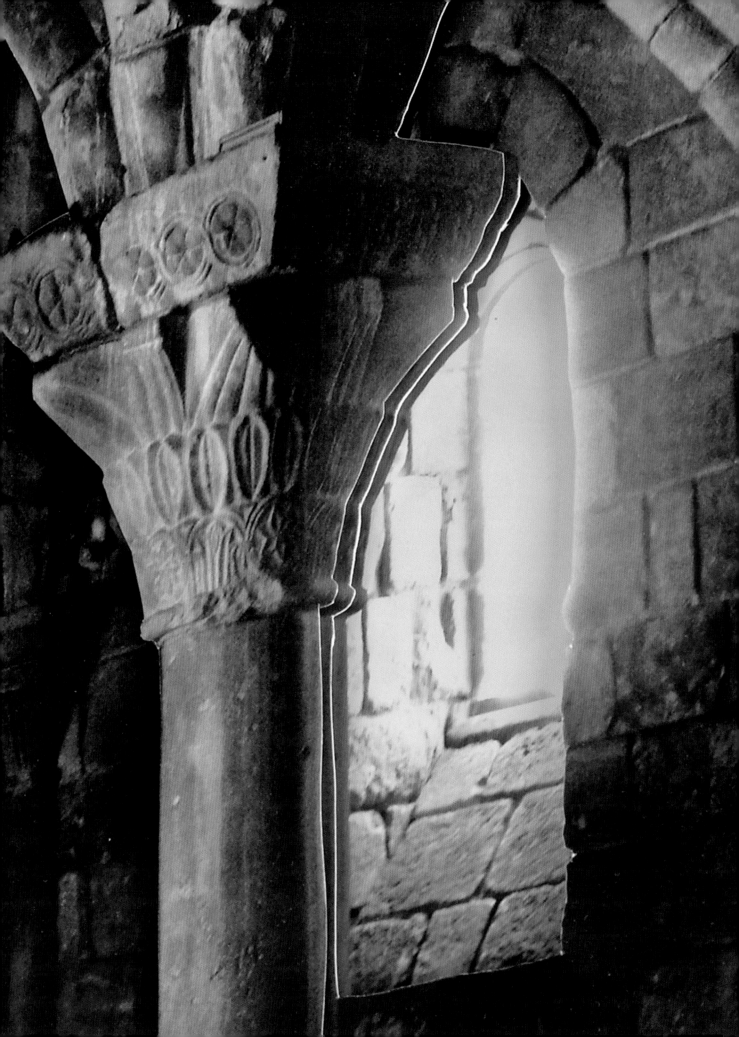

creating projections

Make a photo-relief and take your photography to another level—literally!

Repeating specific areas of a photo in raised layers gives a once flat image new depth and drama.

materials and tools

an enlarged, borderless photograph, three copies, on heavyweight paper

scissors and/or craft knife and cutting mat

adhesive

foam-center board or double-sided foam mounting tape

matboard

Adding a New Dimension

1 Select a photograph with a clearly defined background, middle ground, and foreground. The contours separating each plane should be uncomplicated and well defined. Print it to the 8" x 10" (20.3 x 25.4 cm) size without a border. Make two additional identical prints on cardstock or heavy photo paper.

2 Mount the entire original photograph on matboard for a sturdy support.

3 Remove the background segment from one of the copies (in this case, the sky), using scissors or a sharp craft knife. Discard.

4 Cut rigid foam board (³⁄₁₆" [0.19 cm] thick) into a shape that fits behind the copy (which now includes only the middle and the foreground). Make the foam-center board shape at least ¼" (6 mm) smaller all the way around. Glue the foam-board riser to the back of that copy. Allow to dry. The foam riser will separate this copy from the base.

Pointers from Paula

It may be necessary to use additional, smaller pieces of foam-center board behind images with protrusions. Ask your local picture-framer for scrap pieces of foam-center board (free!) or use double-sided mounting squares or mounting tape if you must.

5 When the glue has set, adhere the partial copy atop the original photograph. Now only the background shows at the lowest level. Here, the lowest (flat) plane recedes beneath the two buildings (the middle and foreground), and we don't stop there!

All three picture planes are well defined, making this photo a good choice for the project.

6 From the second cardstock copy, cut away the farthest and the middle planes. Discard. All that remains is the foreground piece of the image. Cut a foam board shape to fit (a bit smaller) behind it. Glue the riser to the back of the portion.

7 When the glue has hardened, adhere the uppermost photographic piece to the artwork.

In this scene, the wall serves as middle ground, there's a clear-cut background shape (the window opening), and the distinct object in the foreground has simple edges.

framed by the book

Recycle an unwanted book and, at the same time, frame two photos resourcefully.

For this technique, children's board books with heavy cardboard pages are redesigned into clever photo frames. Applying acrylic paint and wiping it off lends an interesting effect to the frame at left. A few dimensional paints from squeeze bottles also accent the frame.

materials and tools

two photos to frame	waxed paper
old board book	adhesive
pencil	acrylic paints
metal-edged ruler	container of water
sharp craft knife or utility knife and cutting mat	paintbrushes
	palette
sandpaper, medium-grit	paper towels or old rags
plastic sheeting and protective clothing	cutting board (optional)
white liquid gesso (or white latex house paint)	decorative papers (optional)

Building a Board Book Picture Frame

1 Select a children's board book with heavy cardboard pages. Open to the center. These two pages will become the mats that frame the photographs.

2 Use the ruler and pencil to measure and mark the guidelines for the cutouts on the two facing pages. Don't place the openings too close to the edges. Leave a margin of about ¾" (1.9 cm) all the way around. These openings will be rectangular, but do use any shape desired!

3 Make sharp, clean cuts (running the blade alongside the metal-edged ruler for straight lines). Several passes will be necessary to cut through the cardboard. Use great care when handling sharp tools. Placing a cutting board between the pages is optional, since scoring below will not show later.

Pointers from Paula

Cutting through heavy cardboard with a craft knife can be tiresome. Substitute a rotary tool for the utility knife and make fast work of the job.

4 The rest of the board pages will form a solid backing for the two frames. Glue the extra pages together. Place waxed paper sheets underneath the two picture mats in the center, to keep glue off them. Then glue the front page block to the book's front cover, and adhere the back page block to the back cover. Leave the book open and place a heavy weight on it overnight.

5 Sandpaper the two pages with openings, and also sand down the book's cover (its front and back) and the spine. Roughening these slick, shiny surfaces helps them better accept gesso. Wipe off the dust.

6 Brush gesso onto all the surfaces on one side, including the edges. Gesso serves as a primer for the impending painting. Let dry on waxed paper; then gesso the other side. Sand lightly when dry.

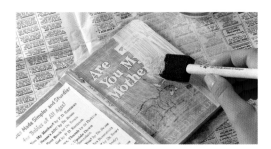

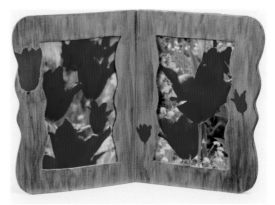

The cut-out openings echo the original edge of the children's book.

7 Paint the center mats (and their edges) in acrylics, using colors that harmonize with the photos to come. Place waxed paper beneath the two pages, so they won't stick to the rest of the book. Blend, dab, or stroke the paint on in any style you wish. When dry, flip the book over and paint that side too.

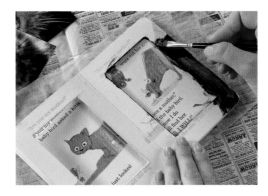

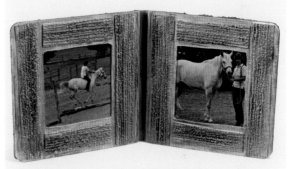

Paintable wallpaper pieces add texture.

8 Center and glue the photographs into place, sandwiching them between the cut mats and the solid book. Then glue down the cut-out pages. Embellish the painted frame, if desired, with decorative papers, printed napkins, or tissue papers.

Pointers from Paula

If the book will be bordering two photos of kids, consider skipping the gesso and leaving the book's cover as is!

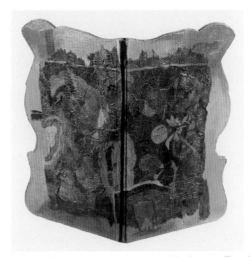

Printed napkins adorn the back of this frame. The front is shown on page 122. The outer edge of the original book has been altered as well.

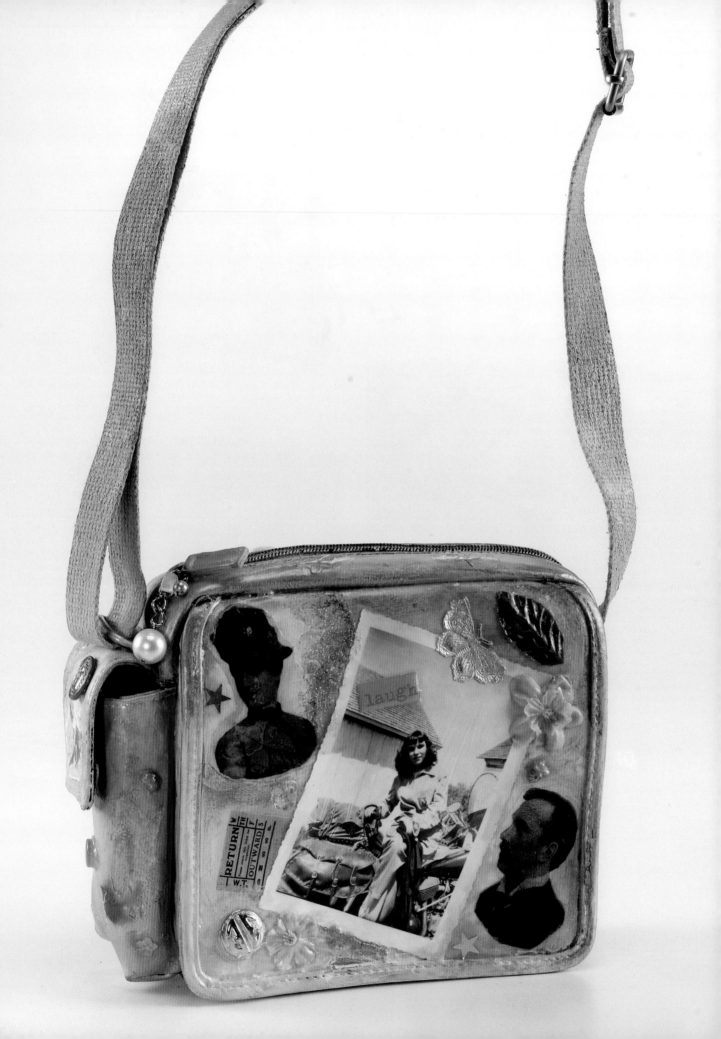

it's in the bag

Create a distinctive collage project using personal photos, a secondhand bag, small objects, and ephemera of all kinds.

This mixed-media activity adapts to containers of all kinds. And it's a cinch! Use a hatbox, a small file case, a lunchbox, a train case, or a fisherman's tackle box.

materials and tools

assorted photographs

a used handbag, case, wooden box, or luggage piece

heavy gel medium

newspapers or plastic table cover to protect work surface

paintbrushes

white liquid gesso or white latex house paint

acrylic paints

palette

ephemera such as postcards, postage stamps, sheet music, and maps

embellishments such as metal charms, fabric flowers, buttons, and more

glue gun and glue sticks (optional)

acrylic spray (optional)

it's in the bag (continued)

Beginning with a Bag

1 Select a firm, unyielding bag (nothing too soft or squashy).

2 Slick materials, or very porous ones, should first be sealed with gesso if they will be painted. Two coats may be required. Even the strap is gessoed.

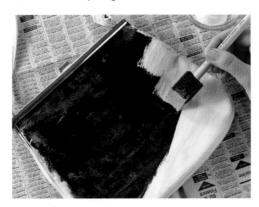

3 When the gesso is dry, paint all the surfaces of the bag or container with acrylics in colors that complement the theme to come. For example, snapshots of the beach might go with cool blues and a sandy accent.

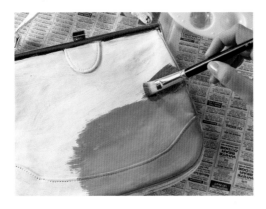

4 After the paint is dry, adhere photographs with heavy gel medium. Use entire snapshots or cut the main subject from the photo if desired. For an irregular edge, tear around photo edges or use edging shears. Besides photos, adorn the bag or container with playing cards, stickers, postage stamps, or more.

5 When dry, seal with a topcoat of clear acrylic spray or gel medium.

Pointers from Paula

Decorate with more than mere paper—use lots of small, fairly flat objects, too! Some ideas: seashells, fine beads, washers, game pieces, bottle caps, puzzle pieces, ribbon, lace, costume jewelry, foreign coins, and feathers. Add zipper pulls or dangles if desired.

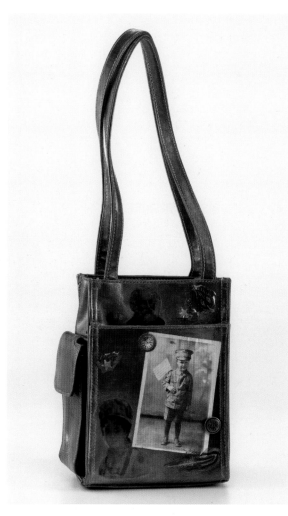

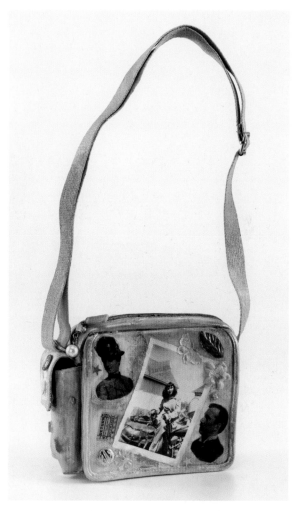

Priming and painting some vessels may be unnecessary. This leather handbag was not primed or painted first.

Use copies of precious vintage photographs (or buy stickers of period images).

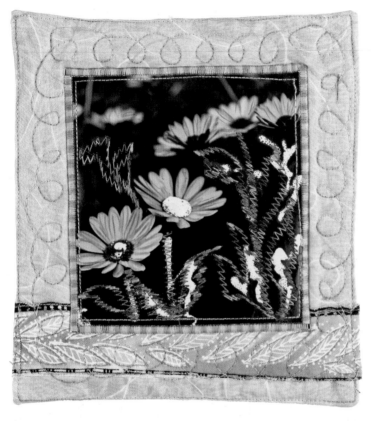

Daisy Sunshine
by Cheryl Olson

Cheryl used a bleach pen in selected areas on a matte-finish photograph, then added color later with photo pens. The photo is mounted on a fabric sandwich, stiffened with heavy stabilizer. Freehand quilting and zigzag stitches add colorful accents while securing the photo.

Fall Breeze
by Cheryl Olson

Cheryl bleached the batik fabric and the photo by pressing a rubber stamp that had been smeared liberally with a bleach gel pen. She used photo pens with cotton swabs to enhance the photograph. The fabric, backed by heavy stabilizer, is embellished with Angelina fibers, ribbon, and string. Freehand stitching secures the layers and melds the photo into the composition.

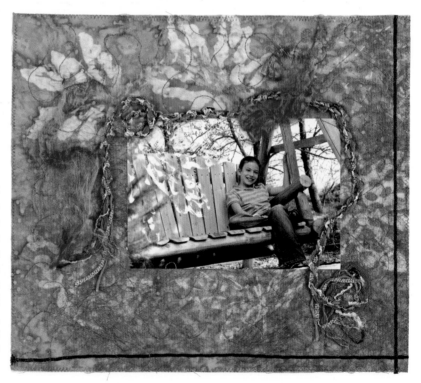

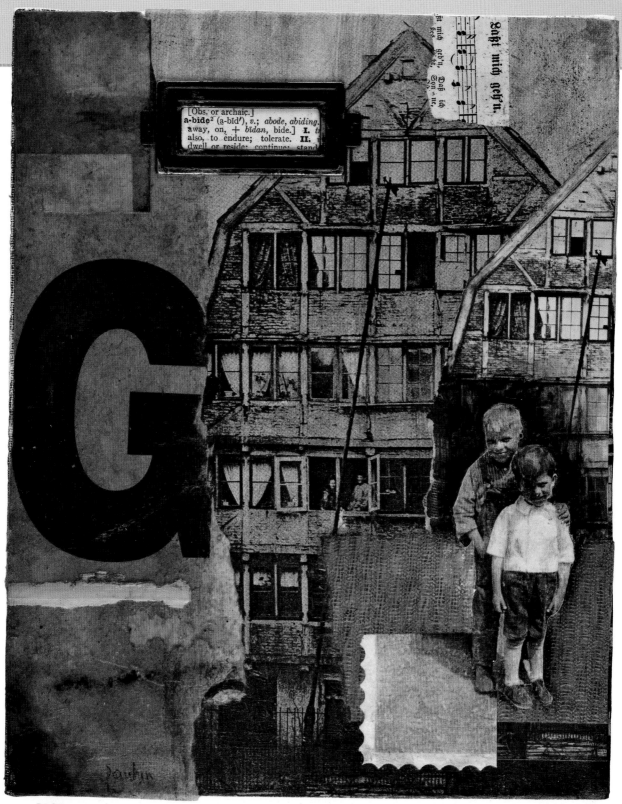

Abide by Paula Guhin
Colored pencil enhances the photocopy of the two boys.

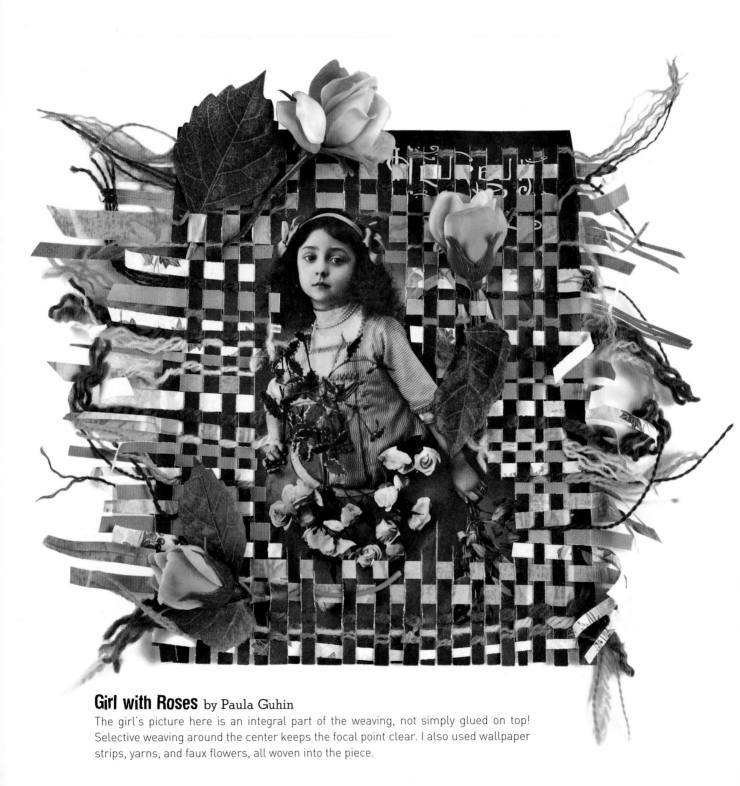

Girl with Roses by Paula Guhin

The girl's picture here is an integral part of the weaving, not simply glued on top! Selective weaving around the center keeps the focal point clear. I also used wallpaper strips, yarns, and faux flowers, all woven into the piece.

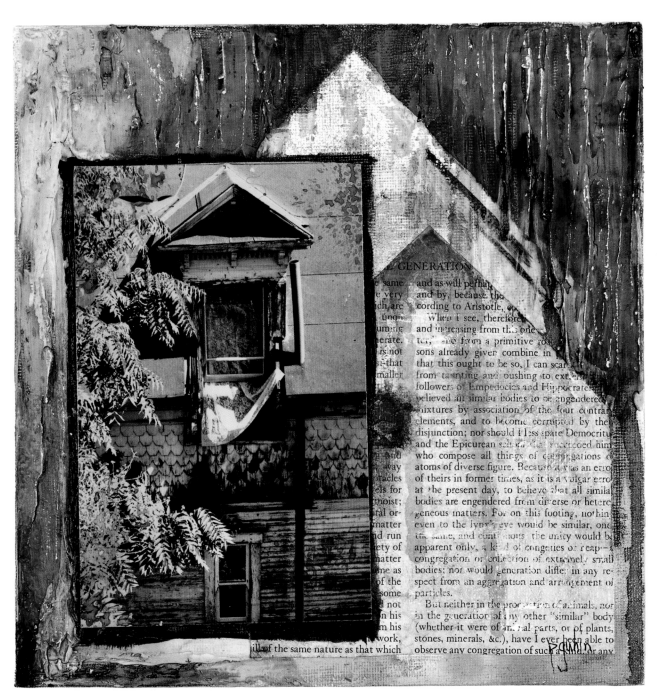

Window by Paula Guhin

The photograph, stained with brown fabric dye, was black and white.
Other materials include acrylic modeling paste, a page from a discarded
book, and acrylic paints.

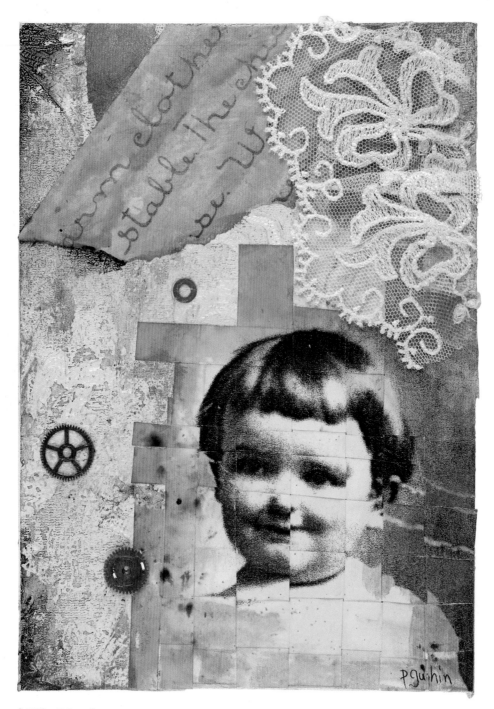

Little Phoebe by Paula Guhin
The background here is wallpaper adhered to a canvas panel. I stained the
weaving and portions of the background with inks and then added a scrap of
childish handwriting, clock parts, and a bit of lace.

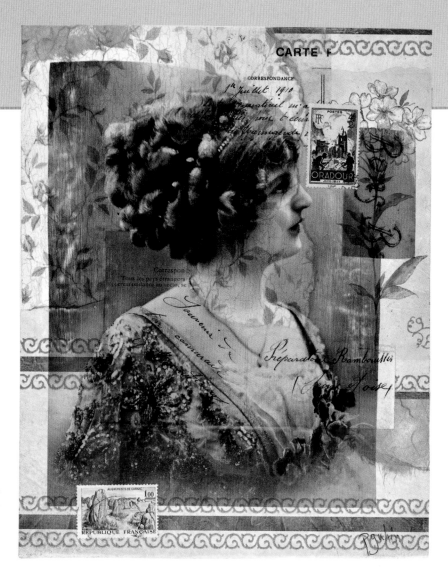

Beloved
by Paula Guhin

This artwork incorporates wallpapers, foreign postage stamps, a very old postcard, and rose-colored mulberry paper, as well as a transparency.

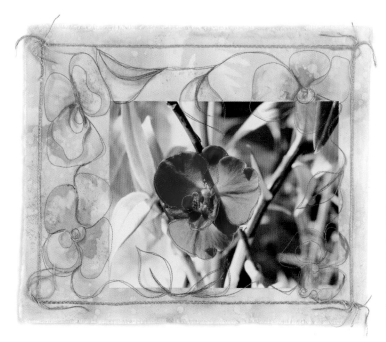

Orchid
by Cheryl Olson

Cheryl made two copies of the image on inkjet photo paper, one black and white and the other colored. She cut the colored flower from its background, then layered it over its black and white counterpart. Freehand stitching attached the photos and added more flowers and leaves, which she enhanced with fabric paint.

She Liked Big Hair by Claudine Hellmuth

Claudine explains: When I'm working in illustration and not on custom artwork using family members, I like to "create" my own photo heads by combining several photo images together to "make" my own people. For example, I'll purchase vintage photos from eBay and then combine a nose from one person with eyes of another and a hairstyle of another person until I arrive at the look I want. This has been a lot of fun and it's very useful, because then I can make sure the photo image fits the context of the artwork.

For "Big Hair" I created a woman with an over-the-top beehive, enlarging an existing hairdo that I scanned in from an old photo. It gave the woman just the look that I wanted!

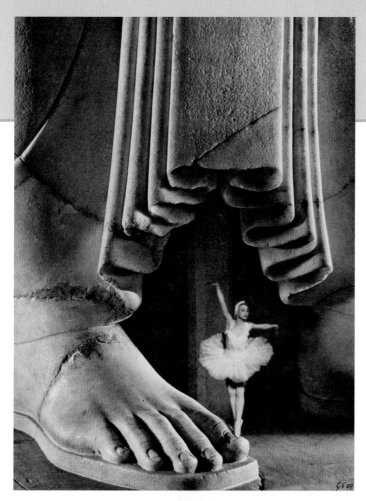

Pointe en Pointe
by Gordon Carlisle

Gordon describes his methods: I collect magazine imagery in portfolios with titles like "Machinery, Vehicles" and "Men, Women, Children." Inside the folios, these are divided into black and white images and color. I usually begin collaging with about ten background images that I think have potential. Often, the collage elements surprise me and take me where they want to go. I do not use any digital processing. All my work is done with Xacto knives and spray adhesive. Sometimes I blend the collage elements further by painting in acrylics.

Hot Dog Wrestling in Florida by Gordon Carlisle

Gordon grew up in the 1950s, with *Life* magazine and science fiction B-grade movies. He recalls that printed color looked more washed out in those days, and that is still the lens through which he sees the world.

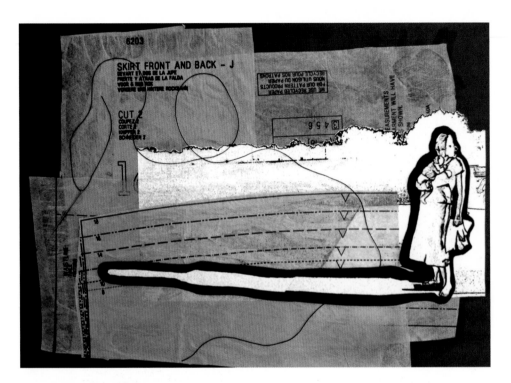

One Size Fits Most by Nicole Fischer

This artwork is composed of a manipulated digital photograph, a sewing pattern, and a needle and thread. Nicole printed out the photo, sandwiched it between layers of the pattern tissue, then cut out and mounted another digital print onto a piece of black matboard. She cut the matboard to leave a slight edge, giving the mother and child more emphasis amidst the busy background. Finally, the needle and thread were carefully composed and attached.

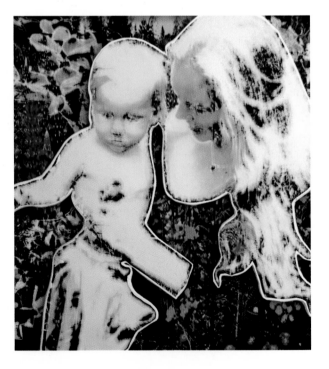

In the Garden by Nicole Fischer

Digital imagery of a mother and child was first desaturated. Then Nicole reapplied tints to warm it up. She printed the image, cut it from its background, and mounted it to a white matboard, leaving a small white edge for more visual impact. She set a spacer under that and placed it atop a background, a photo of wildflowers. Actual size: 10" x 10" (25.4 x 25.4 cm).

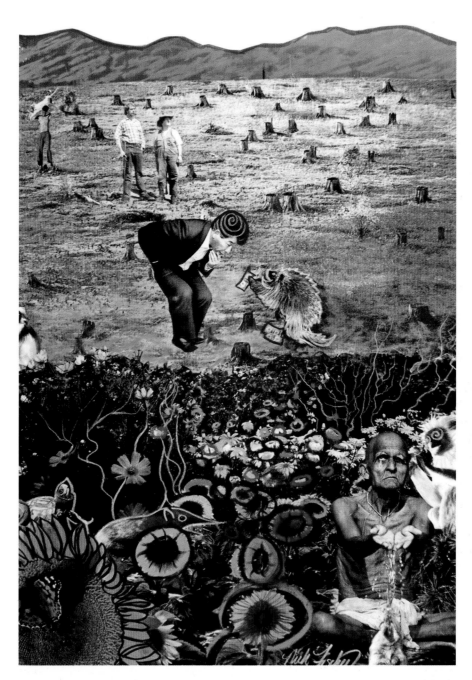

Surreal Landscape by Nick Fischer

Nick used a combination of his own photos and magazine pictures, cut out. He layered them with spatial depth in mind. Next he photographed the montage digitally and desaturated it to better unify the work. After printing it, he hand-colored selectively to add to the surreal quality of the piece. Actual size: 7" x 11" (17.8 x 27.9 cm).

about the contributing artists

Gordon Carlisle

Originally trained as a portrait artist, Gordon is a muralist who also does portraiture, graphics, illustration, theatrical set design, and more. Gordon and his wife live in South Berwick, Maine. His studio is at 855 Islington Street, Portsmouth, New Hampshire, 03801. For more information, email him at info@gordoncarlisle.com and see his website at www.gordoncarlisle.com.

Nicole Fischer

Nicole is a native to the Midwest. Common themes in her work include femininity, motherhood, nature, and religion. She draws inspiration from her surroundings in Minnesota and South Dakota. She earned a B.A. in fine art and Spanish from Northern State University in Aberdeen, South Dakota, where she currently resides with her husband, Nick, and their three children.

Nick Fischer

Nick was born and raised in Aberdeen, South Dakota. The large skies there are featured in his work. Portraits from life are also prominent in his work as a pastel artist and photographer. Nick graduated from Northern State University with a B.A. in fine art. To see more of his and Nicole's work, visit www.fischersart.com

Claudine Hellmuth

Claudine is a nationally recognized collage artist, author, and illustrator. She combines photos, paint, paper, and pen into quirky, whimsical-retro collages that she calls Poppets. Her artworks have been featured on *The Martha Stewart Show*, in *Mary Engelbreit's Home Companion* magazine, on HGTV's *I Want That!* and on the DIY Network's program, *Craft Lab*. In addition to creating her artwork full-time, Claudine teaches collage workshops in the United States and Canada, and she has written two books about her techniques: *Collage Discovery Workshop* and *Collage Discovery Workshop: Beyond the Unexpected*. She has also produced three instructional DVDs.

Claudine's studio and home are in Washington, DC, where she lives with her husband, Paul, and their very spoiled pets—Toby the wonder dog, and Mable and Stanley, the cats.

Cheryl Olson

Cheryl lives on a farm in northeastern South Dakota. She works in many other media besides fiber and photography, including Neriage porcelain, raku ceramics, acrylic paint, and glass bead jewelry. Here's what she says about her creative process: "I've learned to enter a spiritual, enlightening place inside the soul, a place where I can feel peace, joy, and energy. Being a wife and mother inspire me to keep things light and fresh, and not worry about the small stuff."

Email Cheryl at colsonstudio@hotmail.com

last words

Although you've reached the end of this book, think of it as the beginning! There are countless ways to explore and develop your creative talents using this book as a jumping-off place. Communicate your own ideas and emotions, be messy at times, and make accidental discoveries! Of course results will vary due to dissimilarities in papers, inks, dyes, tools, and other art media. But do try new products and different strategies. Experiment with joyful abandon. Never stop learning.

about the author

Paula Guhin is a photographer, mixed-media artist, visual arts educator, and writer. Her nonfiction books include *Glorious Glue!: Art with Adhesives* (J. W. Walch), *Can We Eat the Art?* (Incentive Publications), and *Creative Imaging Projects* (Goodheart-Willcox). Guhin is also a contributing editor at *Arts & Activities Magazine*. She facilitates workshops and demonstrates nationally. To learn more or to contact her, visit her website at www.ArtistAuthor.com. She lives in Aberdeen, South Dakota, with her husband, David, three dogs, five horses, and one cat.

resources

Blick Art Materials
P.O. Box 1267
Galesburg, IL 61402-1267
Phone: 1-800-723-2787
www.DickBlick.com

DecoArt, Inc
P.O. Box 386
Stanford, KY 40484
Phone: 1-800-367-3047
www.Decoart.com

Freestyle Photographic Supplies
5124 W. Sunset Boulevard
Hollywood, CA 90027
Phone: 1-800-292-6137
www.Freestylephoto.biz

Oriental Trading
P.O. Box 2308
Omaha, NE 68103
Phone: 1-800-496-4587
www.Orientaltrading.com

Porter's Camera Store
411 W. Viking Road
Cedar Falls, Iowa 50613
www.Porters.com

index